LEGENDARY

OF

OAK PARK

ILLINOIS

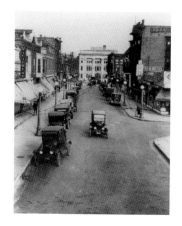

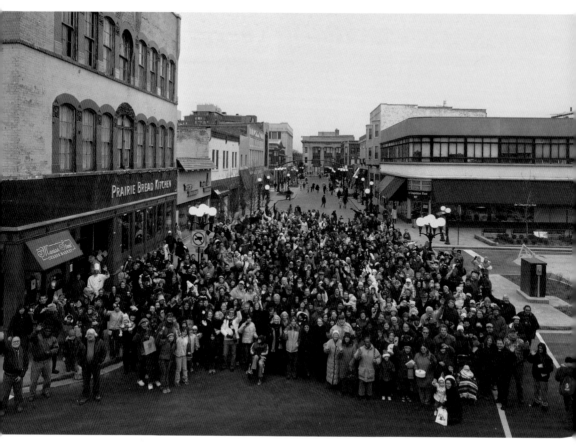

Marion Street, December 2007
Here, a number of Oak Parkers gather to celebrate the reopening of Marion Street, just recently paved with historic bricks. (Photograph by HNK Architectural Photography, Inc.; courtesy of the Village of Oak Park.)

Page 1: Marion Street, 1924
This 1924 view is looking north along Marion Street, with a Victrola store on the left and Oak Park Trust & Savings Bank in the distance on Lake Street.

LEGENDARY LOCALS

OF

OAK PARK

ILLINOIS

DOUGLAS DEUCHLER

LEGENDARY
LOCALS

Legendary Locals is an imprint of Arcadia Publishing
Charleston, South Carolina

Printed in the United States of America

Library of Congress Control Number: 2013930899

For all general information, please contact Arcadia Publishing:
Telephone 843-853-2070
Fax 843-853-0044
E-mail sales@arcadiapublishing.com
For customer service and orders:
Toll-Free 1-888-313-2665

Visit us on the Internet at www.arcadiapublishing.com

Dedication
To all the extraordinary people of Oak Park who did not make it into this one slim volume.

On the Front Cover: Clockwise from top left:
James DeWar, inventor of Twinkies (Courtesy of the Historical Society of Oak Park and River Forest; see page 86); Marjorie Judith Vincent, 1991 Miss America (Courtesy of the Historical Society of Oak Park and River Forest; see page 63); Betty White, actress, comedian, and television personality (Courtesy of the Historical Society of Oak Park and River Forest; see page 99); Doris Humphrey, modern dance pioneer (Courtesy of the Historical Society of Oak Park and River Forest; see page 38).

On the Back Cover: From left to right:
Frank Lloyd Wright, architect (Courtesy of the Historical Society of Oak Park and River Forest; see page 45); Virginia Cassin, village clerk and fair housing activist (Courtesy of the Historical Society of Oak Park and River Forest; see page 23).

CONTENTS

ACKNOWLEDGMENTS

I am grateful for the many generous folks who have been extremely helpful during the completion of this project. Some provided leads to additional sources; others loaned remarkable photographs. The author especially wishes to thank Frank Lipo, executive director of the Historical Society of Oak Park and River Forest, for his unfailing kindness, insight, and support, and Beth Loch for fact-checking and the scanning of photographs. Unless indicated otherwise, all of the images in this book are from the archives of the Historical Society of Oak Park and River Forest. I am appreciative of photograph assistance from Debby Preiser and Edward O'Brien of the Oak Park Public Library. Claire Innes and Andy Mead of the *Wednesday Journal* tracked down photographs, many of which were taken by Jason Geil and Frank Pinc. Thanks also go to David M. Powers, Joe Kreml, Kevin Bry, Diane Pingle, Ken Trainor, Gale Zemel, Jack Crowe, Jean Guarino, Peggy Sinko, Paul Yangas, Allen Baldwin, John Stanger, Christine Vernon, Laurel McMahon, Richard Murphy, Mary Anne Brown, Nicole Balch, Karen Skinner, and Susan Reich. I would also like to thank my wife, Nancy, my sons, Tim and Jason, and my daughter, Samantha, for their enthusiastic support. They are remarkable Oak Parkers, too.

INTRODUCTION

From the beginning, Oak Park forged a strong sense of identity that few towns can lay claim to.

Though first settled when the region was opened up for an influx of eager pioneers in the 1830s, the small frontier northern Illinois village did not really experience a population boom until after the Great Chicago Fire of 1871. Before the ashes had cooled, a large number of displaced families began relocating into the community. Because of Oak Park's location on the west edge of Chicago's city limits, the frequent trains back and forth to the downtown Loop (eight miles east) made the village a highly desirable place to live. By the turn of the 20th century, the community became a population magnet, attracting ever-larger numbers of prosperous, progressive people to settle in what realtors were promoting as "the finest of the streetcar suburbs." The village became an independent municipality when it split from Cicero Township in 1902. The population of 10,000 in 1900 quadrupled to 40,000 by the 1920 census. For years known as the "World's Largest Village," Oak Park today has 55,000 residents.

During the precarious 1960s and 1970s, urbanologists predicted the community would experience rapid white flight and then resegregate as the adjacent racially changing West Side of Chicago would "roll over" Oak Park. But that never happened. Courageous leadership launched an aggressive approach to integration. Ongoing commitment from dedicated residents has created a community that embraces and celebrates its diversity. Today, 67.7 percent of the residents are white, 21.7 percent are black, 4.8 percent are Asian, 4 percent are biracial, and 1 percent are Native American.

Oak Park was never just an anonymous bedroom suburb. From its earliest days, its 4.6 square miles have been a veritable hothouse for the cultivation of noteworthy individuals. The village has produced several governors, a presidential assassin, a Miss America, an astronaut, various Pulitzer Prize winners, movie actors and television stars, plus an amazing assortment of inventors, scientists, mobsters, and musicians. They have changed the course of American literature and architecture; they have discovered sickle cell anemia, coronary thrombosis, and synthetic cortisone; they have altered traditional sociological perceptions about changing neighborhoods. Oak Parkers have given the rest of the world yo-yos, Big Macs, Twinkies, Tarzan, Lincoln Logs, and slot machines.

There is also an astonishing number of energized, creative folks whose names may not exactly be household names but who keep Oak Park a vibrant, dynamic place. The village has long been associated with progressive architecture, culture, and community spirit.

Oak Park lawyer, actor, and historian Kevin Bry has written, "The people of Oak Park have chosen this community not so much as a place to live, but as a way of life."

Tourism is a key industry in Oak Park. The Frank Lloyd Wright and Ernest Hemingway historic sites alone attract over 200,000 visitors each year.

Oak Park people have long been known for their social consciousness and their community involvement. In the 2012 presidential election, Oak Park had the highest voter turnout in suburban Cook County. The *Reader* newspaper rated Oak Park "Best Suburb" of 2012. *Family Circle* magazine chose Oak Park as "Best Suburb for Families" in 2012. In 2013, the American Planning Association named Oak Park one of "the 10 best neighborhoods in the United States."

The Historical Society of Oak Park and River Forest offers numerous opportunities to find out more about this unique community through its website, museum, research center, and frequent events. The group conducts periodic "Hometown Legends" trolley tours assisted by the author and other local historians.

Join me as we meet over 100 exciting Oak Park people, past and present, who have made the village so fascinating and unique.

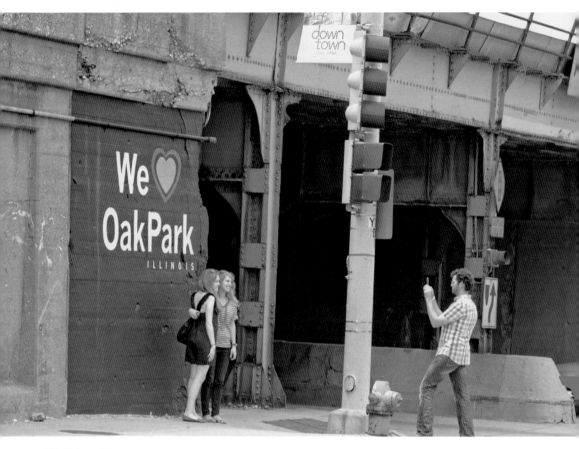

Walking Tour
A trio of young visitors, having arrived in the village via the Green Line elevated, pause for a photograph at the viaduct at Harlem Avenue and North Boulevard before setting out on a stroll through Oak Park's Historic District. (Photograph by Nicole Balch.)

CHAPTER ONE

Creating Community

There is a slang term that longtime residents still use: "Dooper." The origin of this word is vague, but its definition is precise. Doopers are enthusiastic Oak Parkers who tirelessly promote and support their beloved village's image. Perhaps, the term derived from the word *super-duper*, an adjective applied to something really awesome or amazing. Older community members insist it is simply an acronym for "Dear Old Oak Parkers"—those proud, energized boosters who are indefatigable cheerleaders for their village.

An entire volume could be written celebrating Doopers. There has never been a shortage of Oak Park builder-uppers. Jim McClure (born in 1920) was a courageous village president during the 1970s, a crucial decade when the village addressed racial change, economic development, and school reorganization. "Bud" Corry (1925–2002) was a beloved, enthusiastic director of recreation who rescued Works Progress Administration (WPA) mural art, now restored and on exhibit at the Historical Society of Oak Park and River Forest. Vince Dierkes (1917–1999) started Oak Park's youth baseball program. Sara Bode (born in 1935), the first woman village president in 1981, promoted regional and national visibility for Oak Park. She boosted economic growth in the east end adjacent to Chicago's West Side to counter perceptions of that neighborhood being at risk.

In the anxious years of the 1960s and early 1970s, when many predicted doom for Oak Park, there were valiant folks who worked hard to redefine and build on the values of the suburb. Realtor Rich Gloor (born in 1937) recognized the strength Oak Park could wield by marketing itself as a diverse suburb. He became a tireless ally in the village's commitment to achieving lasting integration. Frank Muriello (born in 1930) fought blight in Oak Park by rehabilitating decaying rental buildings, thus helping to stabilize the real estate market in the east Chicago border neighborhoods and reinforcing the community's successful integration efforts.

Diana Carpenter (born in 1945), active with the Building Owners and Managers Association (BOMA), was a relentless advocate for Oak Park's east end, fighting an often myopic, self-defeating local tendency to steer people away from that Chicago border neighborhood.

Each month, as demand continues to skyrocket, volunteers donate 1,500 hours of labor to feed their needy neighbors through the Oak Park and River Forest Food Pantry while many more unsung Oak Park heroes assist the homeless through PADS (Public Action to Deliver Shelter).

During the 1970s, Oak Park moved from being a predominantly conservative suburb to a more liberal community. In 1976, Oak Park was declared by the National Municipal League (now the National Civic League) to be an All-America City, one of 10 municipalities to receive the distinction that year.

The village seems to thrive on volunteerism, social activism, and energetic community involvement. Some might criticize Oak Parkers as being full of themselves and that they are know-it-all, 1960s-style do-gooders who think they have all the answers. Many residents might nod in agreement and then ask, "So what's wrong with that?"

This chapter showcases 31 of Oak Park's many Doopers.

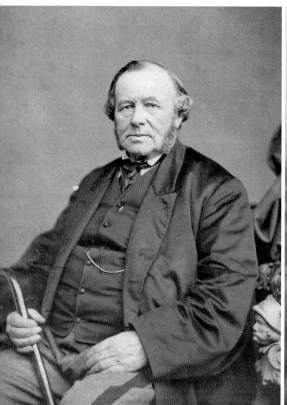
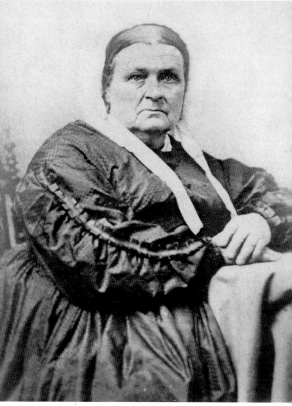

Joseph (1808–1883) and Betty Kettlestrings (1802–1885)

They came from Yorkshire, England. After the Black Hawk Indian War, when the northern Illinois frontier territory was opened up in the 1830s, an intrepid young pioneer couple, Joseph and Betty Kettlestrings, pushed their way through the vast prairie and scattered timber that is now the West Side of Chicago. They stopped along the Indian trail that became Lake Street when they were too exhausted to keep moving. Betty, who was six years older than her husband, announced, "This is as far as we go." Frontier life was often harrowing. Betty bore 11 children; four died in infancy during periodic epidemics. Yet, the hardy Kettlestrings kept going. Since Chicago was a full day's journey from Oak Park, they opened an inn where travelers could get lodging, with supper and breakfast, for 50¢ a night. When the government offered the land upon which they had been squatting for purchase, Joseph and Betty bought 172.78 acres of what is now central Oak Park for $215.98, or approximately $1.25 an acre. By the time photography came along, the couple was up in years. Sadly, there is no shot of Betty, 30, and Joseph, 24, when they first arrived—brave and energetic, embarking on their wilderness adventure together.

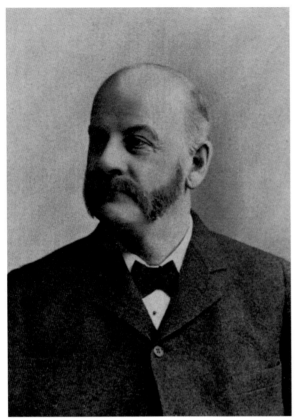

Edmund A. Cummings (1842–1922)

Edmund A. Cummings was so influential and respected that there was a movement to rename Harlem Avenue in his honor after his death. When the Civil War broke out, the 19-year-old Cummings enlisted in the 127th Illinois Brigade. He served with Gen. Ulysses S. Grant at the Siege of Vicksburg and with Gen. William Tecumseh Sherman on his infamous March to the Sea. In 1869, he established E.A. Cummings & Co., one of the best-known real estate firms in the region. After the Great Chicago Fire of 1871, he recognized the population boom in Oak Park and subdivided the small town of Ridgeland, now the east section of the village. Cummings founded the Cicero & Proviso Street Railway Company, which served the booming new western suburbs, especially the 200 subdivisions his firm developed. The Madison Street streetcar, seen in 1902, is picking up passengers at Ridgeland Avenue.

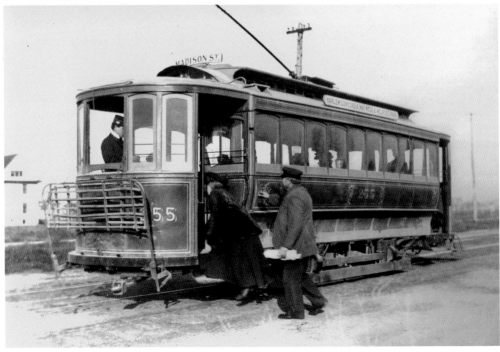

Col. Arthur Rehm
(1870–1941)

Arthur Rehm was one of the key developers of south Oak Park. He was usually referred to as colonel because of his military background. In his 20s, he joined the 2nd Regiment of the Illinois National Guard and was called to active service at the outbreak of the Spanish-American War in 1898. As a second lieutenant in Cuba, Rehm contracted typhoid fever and nearly died. When his old regiment became the 132nd US Regiment at the onset of World War I, 47-year-old Rehm reenlisted. He became colonel

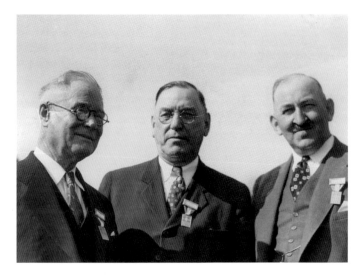

when his troops were sent to what became known as the Mexican Border Incident. Rehm was long a force in Oak Park community affairs and always championed his prairie-like south Oak Park neighborhood. There were wooden sidewalks in just a few places and no paved streets. Mail delivery and police protection were spotty at best. When Oak Park established its park system in 1912, Rehm was elected commissioner. For years, he was routinely reelected and eventually became president of the board. Rehm Park and Pool at 515 Garfield Street is named for him. Pictured below is a May Day event in Rehm Park in 1937. Rehm (left) is seen above with park officials Fred Comstock (center) and Gustaf Lindberg (right).

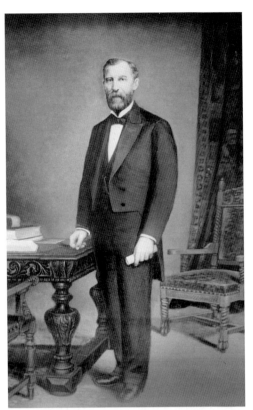

James Scoville (1825–1893)

James Scoville was a self-made millionaire who lived in a 20-room Victorian mansion situated at the top of the hill where the World War I monument now stands in the newly redesigned park that bears his name. He contributed generously to every local civic and cultural cause of his era. Despite his dour appearance in portraits, he was said to be warm and fun-loving. Following his boyhood of extreme poverty, Scoville, in true Horatio Alger fashion, had pulled himself up by his bootstraps to become the president of the Prairie State Bank in the Loop. In 1868, he became a real estate entrepreneur by purchasing and developing much of the Ridgeland zone that is now eastern Oak Park. He supervised every detail of his subdivisions, from laying out the streets, sewers, and sidewalks to planting the trees. But Scoville is best remembered for his 1886 gift to the community of a library, a Romanesque, castle-like structure that became the cultural hub of Oak Park. Seen in 1928, the building was demolished and replaced in the 1960s. The third and current library, a popular hub of the community, was erected on the site in 2003.

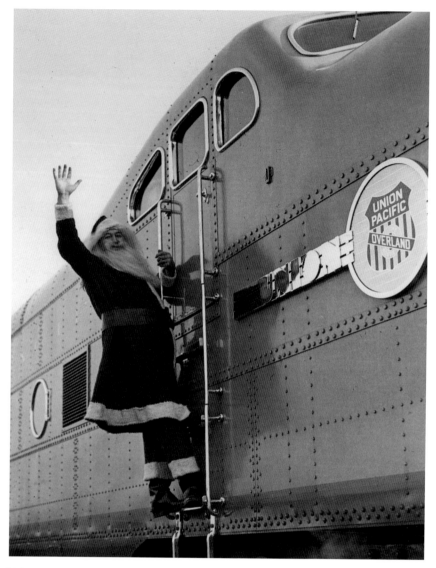

Gustaf Lindberg (1890–1941)

His Swedish immigrant father worked in the landscaping business. That is where Gus Lindberg learned the ropes. In 1912, the newly formed Park District of Oak Park began acquiring land for its park system. A 22-year-old Lindberg was brought in to do the design work. Jens Jensen, the great landscape master, was his mentor. While Lindberg was park superintendent during the 1920s and 1930s, Oak Park's parks became much-visited and often-imitated models of style and grace. His designs were nationally recognized for their "great beauty within urban congestion." People were also drawn to his warm, fun-loving personality. Each year, at holiday time, the playful, energetic Lindberg would dress up like Santa Claus and ride to downtown Oak Park aboard the Denver Zephyr streamliner. He knew that the grand arrival of St. Nick would attract hundreds of families, giving local merchants a much-needed boost during the Great Depression. Even Lindberg's closest friends never knew the identity of this mysterious, jolly holiday visitor. After the Chicago World's Fair closed in 1934, he rescued entire gardens being dismantled and transplanted them into his community. The park formerly known as Green Fields, located 1151 North Marion Street, was later renamed to honor Lindberg.

Galen and Marge Gockel

It is often said that "Oak Park is a better place because of Galen and Marge." Galen Gockel (born in 1932) was one of the architects of Oak Park's campaign to welcome African Americans without sparking white flight during the turbulent, insecure 1960s. Galen and Marge (born in 1933) even acted as straw buyers for a black couple who were having trouble seeing homes due to uncooperative realtors. Galen was the first school board candidate to call for a racially integrated school system, and when many minority families were moving into east-central "border zone" Oak Park, he recognized the negative effect of this pattern on the housing market and authored a plan to create junior high schools and begin busing students to achieve "managed integration." Galen and Marge's house was one of the dozens razed to make way for the new village hall in the 1970s. Oak Park officials felt residents in the east end Chicago border zone would feel more secure with the police and local government in their

neighborhood rather than downtown. Galen, a former township assessor, village trustee, and college professor, has also been a leader in the arts, serving as the president of Oak Park Festival Theatre and with the Civic Arts Council and Unity Temple concert series. Marge and her friend Carla Lind convinced village trustees in the early 1970s that a farmers' market would be a positive offering for the community. Marge brought the Saturday event to the Pilgrim Church lot at 445 Lake Street. Every Saturday from June through October, there are now over 35 vendors participating. In addition to the farm-fresh produce, flowers, and the 200 dozen donuts made on-site, a 20-piece bluegrass band is also a huge draw. Marge is also a member of the Frank Lloyd Wright Preservation Trust and has served on its board. (Both, courtesy of *Wednesday Journal.*)

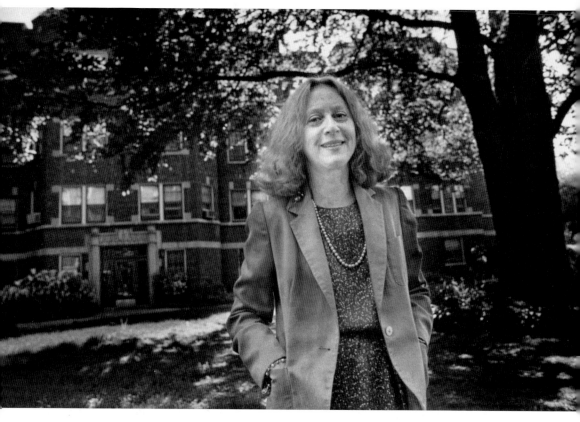

Roberta "Bobbie" Raymond

There is no denying that artist and sociologist Roberta Raymond (born in 1938) had a major impact on Oak Park during a vulnerable, volatile period. She was one of the key heroes to emerge out of the turmoil of the fair housing movement. Bobbie started out in the limelight as a child performer on radio and early television. After working as an actress in New York City, she returned home to find her community in conflict. In the 1960s, the adjacent West Side Chicago neighborhood called Austin was experiencing rapid racial turnover. As whites fled, African Americans continued moving westward. So-called panic peddlers went block-by-block, convincing terrified white homeowners to sell cheap while they "still had a chance" and then gouging incoming blacks with top-dollar prices. While she was a senior copywriter for a Chicago ad agency, Bobbie pursued her master's in sociology from Roosevelt University. The concept for the Oak Park Housing Center came directly out of Bobbie's master's thesis. In 1972, when many Oak Parkers doubted that the community could maintain racial integration, Bobbie founded the Oak Park Housing Center and became its executive director. Committed to the idea of racial balance, the organization sought to encourage African Americans from concentrating in the port-of-entry border zone of east-central Oak Park and to motivate whites to keep moving in. Many predicted Oak Park would completely resegregate ("turn black") by 1980. There were few role models for a successfully integrated community. But Bobbie and the dedicated staff and volunteers at the Oak Park Housing Center were able to maintain diversity in the rental housing stock. Although her efforts were a major factor in Oak Park's nationally recognized campaign to establish and promote a diverse, desirable community, Bobbie always clarifies that such a project is never a done deal. Her grandson Trevor is a fifth-generation Oak Parker.

Adele Maze (1888–1957)

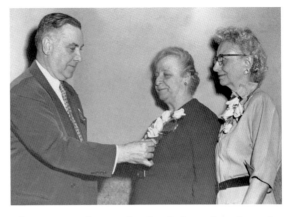

Several generations knew and loved the warm, wonderful "library lady." In the 1910s, Adele Maze became librarian of the South Branch of the Oak Park Library, then located in a rented storefront next door to a silent movie theater called The Elmwood. (Both of these buildings were razed in the 1950s to clear room for the Eisenhower Expressway.) Maze was always thinking of fun ways to motivate neighborhood kids to read more. In 1921, she instituted her weekly story hour, a program that was soon imitated at countless other libraries. She loved films and worked hand-in-hand with the adjacent movie house, planning tie-ins and movie parties when pictures like *Robin Hood*, *The Last of the Mohicans*, *Pollyanna*, or *Treasure Island* were playing. Unlike many librarians and educators of the period who denounced motion pictures, radio, and comic books, Maze became an authority on using media to bridge the gap with youth. She often addressed the American Library Association on the topic of "Making the Library a Community Center." When it was too cold to take the neighborhood kids Christmas caroling, she would crowd them into the drugstore on the northeast corner of Ridgeland Avenue and Harrison Street to warm them up with hot chocolate. She is seen in the 1950s between library official Kenneth Sperbeck and fellow librarian Florence Moyer. At 68, she died of a sudden heart attack while on the job in the library. The South Branch Library, designed by E.E. Roberts in 1936 and constructed at 845 Gunderson Avenue with WPA resources, was renamed the Maze Library to honor her.

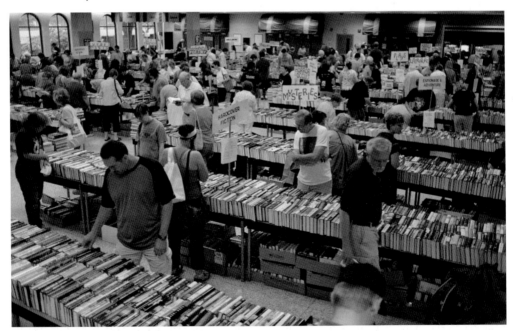

Oak Park Library Book Sale

Sponsored by the Friends of the Library and run by an army of volunteers, the annual sale has been a highly anticipated August event for several generations. Swarms of booklovers buy literally tons of donated books, tapes, and records at the two-day sale that helps support library programs.

Fremont Nester (1903–1976)

Cartoonist Chester Gould is said to have modeled his comic strip character, hard-boiled but intelligent police detective Dick Tracy, on him. Fremont Nester started out as an Oak Park patrolman during Prohibition in 1925 and retired as chief of police during the challenging, volatile open housing turmoil of the late 1960s. His officers often grumbled that he was too demanding and that he was too much of a stickler. But under his leadership, the Oak Park Police Department was recognized throughout the nation for its outstanding record. Perhaps Nester's finest hour was when African American families began moving into the village from Chicago's West Side. Nester surprised many reluctant white residents when he turned out to be a staunch ally of the fair housing movement. He routinely posted squad cars in front of the home and kept them stationed on the block for some

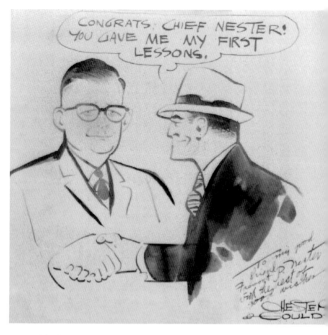

time after the new family arrived, just to be sure. He himself went up and down the blocks to cool down volatile situations. Nester wisely elicited assistance from potential young troublemakers to help keep neighborhood tempers from flaring. He assigned officers to protect the demonstrators who were protesting unfair real estate practices in weekly Saturday marches along Lake Street. To reward him for his long and distinguished career in local law enforcement, Nester was given a new 1970 Oldsmobile at the time of his retirement.

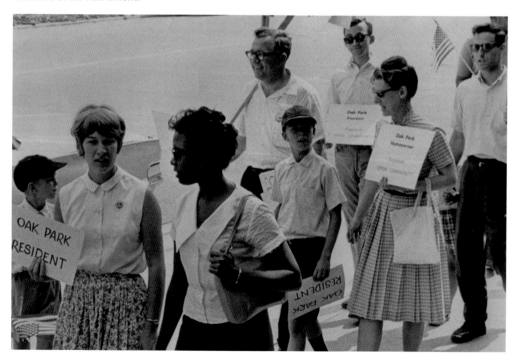

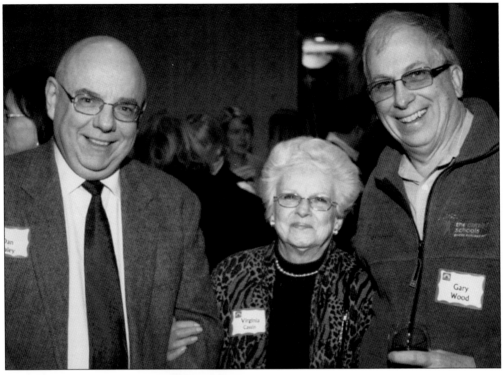

Dan Haley

At the age of 10, native Oak Parker Dan Haley (born in 1955) launched a mimeographed newspaper for his block on South Taylor Avenue. After graduating from Roosevelt University and working a few years in various Oak Park bookstores, Dan Haley turned down the job of lively arts editor at the *Pioneer Press/Oak Leaves*. Instead, he and two other founding colleagues, Anne Duggan and Sharon Britton, rounded up 65 locals to invest in a new independent weekly local newspaper, the *Wednesday Journal*. Dan has been the editor and publisher since its first issue on July 31, 1980. In his weekly column and editorials, he has long been the master of ceremonies overseeing the ongoing public conversation of the topics of the day. Through charm, wit, and by occasionally calling a spade a spade, his columns set the tone for public discussion in Oak Park. Haley is a strong believer in the special place Oak Park plays in improving racial integration and race relations. Dan is seen above with Virginia "Ginie" Cassin and Gary Wood. (Above, courtesy of *Wednesday Journal*; left, courtesy of Karen Skinner.)

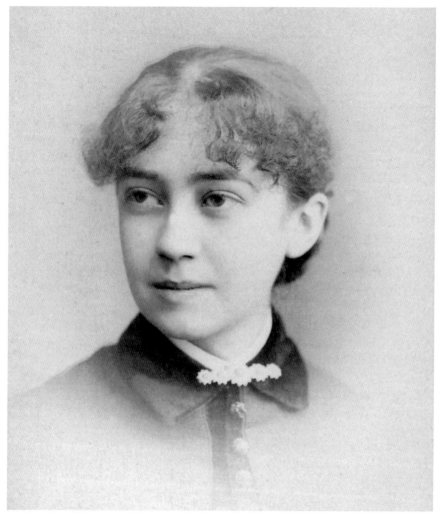

May Estelle Cook (1866–1961)

When she was in her 90s, May Estelle Cook (Oak Park High School class of 1884) was still one of the most active, enthusiastic, energized women in Oak Park. She was especially known for her strong interest in government and politics. Never married, Cook earned her living teaching English at nearby Austin High School. She was a charter member of the Nineteenth Century Club, founded in 1891, which was not only social and philanthropic in scope but also emphasized cultural enrichment. For 35 years, she was on the board of trustees at the Scoville Institute (Oak Park Public Library). Though she came of age in the Victorian era—when young girls were trained to be decorative and unchallenging—May fought her battles "like a lady." She campaigned for everything from workers' rights for "sweatshop women" to the creation of Starved Rock State Park. She helped found the Oak Park Community Lecture series, which lasted from 1900 to 1979, the longest-running lecture series in the nation. In the period before radio and television, Cook arranged for hundreds of big-name lecturers, like Carl Sandburg and Paul Robeson, to enrich the cultural life of her community. In the local elections of 1957, when May was 91, she told the campaign manager, "Give me the hard ones." She scoured Oak Park, ringing doorbells, climbing apartment stairs, and persuading reluctant voters to "come out and make a difference." Cook's charming history, *Little Old Oak Park*, which includes her childhood memories of the Great Chicago Fire, was published the day before her death at 96.

Lee Brooke

Lifelong Oak Parker Lee Brooke has been publishing numerous books about his hometown for over three decades. Born in 1930, Lee has deep roots in the community. His great-grandparents settled in Oak Park in the late 19th century. In the 1960s, Lee was pivotal in the movement to open the village to a racially diverse population by creating a fair housing committee. He has also enjoyed a varied career as a musician, an English teacher, a writer, a medical librarian, and a salesman. But the one job Lee is most proud of is his role as chronicler of Oak Park culture and history. His photograph is from *Let's Eat Out* (1985), Lee's restaurant guide that explores dining options in the village. He has documented notable events, people, and places in Oak Park—from the desegregation and fair housing struggle of the 1960s, in which he was personally involved, to the story of pioneers Joseph and Betty Kettlestrings. Lee has coauthored a number of his recent books with good friend Marcy Kubat.

Arthur Replogle (1923–1999)

He was a war hero when he was only 20. A kamikaze pilot in the Pacific sank Art Replogle's ship, Navy destroyer USS *Luce*, during World War II. He floated for many hours without a life jacket in shark-infested waters before being rescued. Art became an executive of the family-owned business, Replogle Globes, Inc., the world's largest manufacturer of globes, founded by his uncle Luther in the 1920s. Art left that post to sell Oak Park instead of globes. In the early 1970s, he helped negotiate the purchase of the Frank Lloyd Wright Home & Studio, a move now credited with establishing the key role of tourism in Oak Park. He helped found the Oak Park Development Corporation (OPDC), a not-for-profit organization that was formed by local financial institutions in partnership with the village government in 1974. His job as executive director was supposed to last just a short time. But Art ended up serving as president for 23 years. He loved promoting economic development in Oak Park. His hard work had a major impact on Oak Park during a potentially precarious period. Art's involvement stimulated millions of dollars in business investments, countless construction and rehab projects, and hundreds of new jobs in Oak Park.

Josephine Blackstock (1887–1956)

She was the founding director of playgrounds for the Oak Park Playgrounds Commission in 1921. Under the leadership of Josephine Blackstock, neighborhood playground and recreation field houses were built in all local parks. At her insistence, each was named for a children's author (Lewis Carroll, Robert Louis Stevenson, and so on) instead of politicians. In 1931, in the depths of the Depression, after voters approved a bond issue to create Barrie Park, Blackstock received a letter from J.M. Barrie, author of *Peter Pan*, thanking her for the honor of using his name. Blackstock herself was the author of at least seven children's books, the most well known being *Songs for Sixpence*, which is still in print. During the lean

1930s, she pushed Oak Park officials to hire college students to teach crafts, direct shows, and supervise sports to keep everyone occupied during the hard times. She created outdoor festivals and community programs. Hundreds of kids performed in her annual "Summer Circus" before thousands of Oak Parkers. Blackstock established softball and basketball leagues, a junior police force, several playground bands, and created a parks newspaper produced entirely by children. She launched an Aviator Club, open to both boys and girls, which was endorsed and visited by aviatrix Amelia Earhart. Blackstock, who made Oak Park a national model in the recreation field, created and supervised the "Enchanted Island" children's playground at the Chicago Century of Progress World's Fair in 1933–1934.

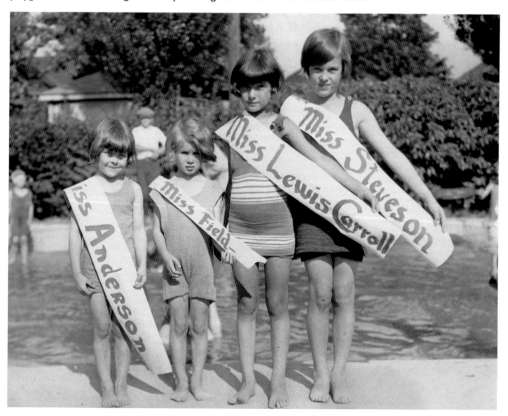

Virginia Cassin

Born in 1924, she raised six children yet still had time for total commitment and involvement in her hometown. Class of 1942 Oak Park High graduate Virginia Cassin was the longtime village clerk (1973–1993) who was instrumental in implementing Oak Park's first liquor licensing and cable television ordinances in the 1970s. She was also a staunch fair housing activist during the 1960s. When she retired from village hall, she never slowed up a bit. "Ginie" Cassin became a board member of the Ernest Hemingway Foundation and, with her husband Bill, was pivotal in the restoration and decoration of the Hemingway birth home. She has been active in over a dozen local organizations. Ginie's enthusiastic and energetic support of Oak Park has provided a strong role model for several generations.

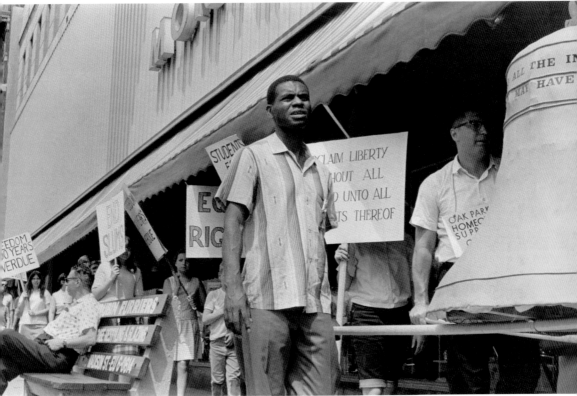

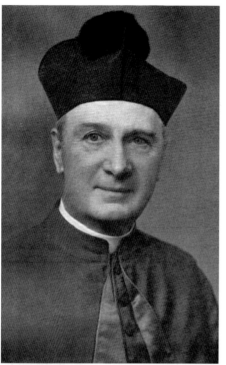

Msgr. John Code (1868–1956)

Though Oak Park was long known as the "Village of Churches," many people in the Protestant majority of local movers and shakers of 1900 were blatantly prejudiced against Catholics, fearing a Catholic church might create an "invasion" of European immigrants. When enterprising young father John Code sought to offer his first Mass in Oak Park on July 12, 1907, no one would rent him a hall, let alone allow him to purchase property. So 50 Catholic families met in an abandoned barn on the Scoville estate (where the tennis courts are now located in Scoville Park). Magnanimous millionaire John Farson, though not a Catholic himself, allowed Father Code to use his grounds (now Mills Park) for a lavish fundraiser. As soon as Farson delivered his welcoming speech, local resistance to the struggling new church group subsided. In 1910, St. Edmund Parish opened its doors. Code often spoke to business groups and community organizations, ever striving to improve relations and understanding among villagers. When he died in 1956, 88-year-old Monsignor Code was the only priest in the diocese to have served 50 years in the parish he founded.

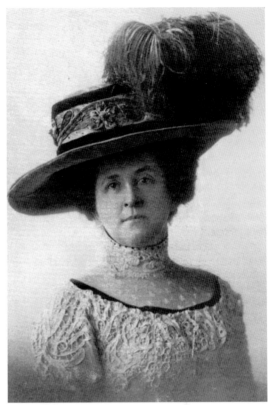

Grace Wilbur Trout (1864–1965)

She was a well-to-do matron who could have filled her days attending ladies' luncheons and tea parties. Yet Grace Wilbur Trout became a courageous and outspoken leader in the struggle for equal rights. Using women's clubs as her network, Trout tirelessly organized campaigns, protests, lectures, and parades. She was the elected president of the Illinois Equal Suffrage Association. The press routinely criticized her French-designed attire and her proclivity for huge, profusely decorated hats. Yet reporters were also often in awe of Trout's passion, her bravery, and her flair for public speaking. In 1910, she began widely publicized "Automobile Crusades"—motor tours that featured speakers and rallies all across the state. She led several massive marches through the Loop, as seen here in 1916. Trout became a nationally significant suffrage leader who consulted with both Presidents Taft and Wilson.

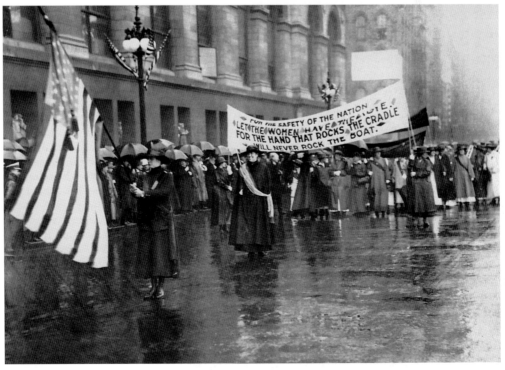

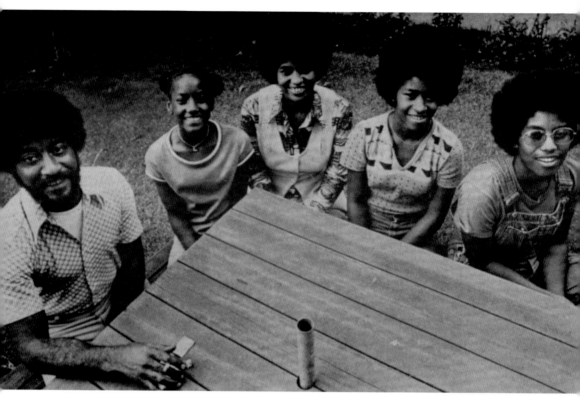

Sherlynn Reid

For three decades, with passion and commitment, she helped change and shape positive attitudes about working and living alongside people of different races, ethnic groups, and lifestyles. Sherlynn Reid (born in 1935) made promoting racial diversity in Oak Park her mission. In 1968, shortly after the local fair housing ordinance passed, 33-year-old Reid, her social worker husband, Henry, and their three young daughters moved into Oak Park. Sherlynn and Henry were the first African American couple to purchase a home with a conventional loan from a local bank. She spent the next 27 years at village hall in community relations, rising to become its director as the capstone of her career. She held the role of full-time "harmonizer" during a period of great insecurity about whether Oak Park might reach a tipping point when the number of blacks moving into town would cause panic and white flight. Sherlynn's responsibilities included enforcement of the new fair housing law by working with realtors and multiunit housing owners and managers. As an African American, she lent credibility to village initiatives that might be seen as "racial steering." Her strength, poise, and dignity were Reid's hallmark. She also served as president of many organizations, from the League of Women Voters to the Nineteenth Century Club. Sherlynn is seen with her husband their three daughters in 1977. They are, from left to right, Henry, Lorie, Sherlynn, Dorothy, and Mary Reid.

Henry W. Austin (1828–1889)

Oak Park was dry for a solid century because of this man. In his 20s, Henry Austin began a thriving business selling pumps and other hardware to the waves of settlers who had begun clearing the region in the 1840s. He quickly climbed from traveling salesman to successful manufacturer. In 1859, Austin purchased six acres of prime central Oak Park land, a square city block, where he built his bride a seven-gabled house facing Lake Street. The house was located where the 1936 Lake Theater now stands. Austin then purchased a 280-acre farm just east of Oak Park and split it into six residential subdivisions in 1866. He personally planted trees and imported a boxcar full of squirrels. When he was done, he named his new village Austin, after himself. His real estate fortunes really grew after the Great Chicago Fire when the far West Side experienced a population boom. Austin next founded a bank and became its president. But he is often best remembered as Oak Park's leading temperance advocate. Vehemently opposed to the consumption of alcohol, he purchased all the saloons in the early 1870s and then personally dumped every drop of liquor into the streets. His edict of local prohibition remained in place until the 1970s. The large Austin home was razed in the mid-1960s before local preservation became an Oak Park mantra. But the remaining Austin carriage house is still used every summer as the dressing room for Oak Park Festival Theatre's outdoor performances in Austin Gardens, the lovely public park created from the Austins' former yard on Forest Avenue just north of Lake Street. Seen below at center are, from left to right, Jack Hickey, Dennis Grimes (in the title role), and Jude Roche in the 2011 Oak Park Festival Theatre production of Shakespeare's *Henry V*. (Below, courtesy of *Wednesday Journal*.)

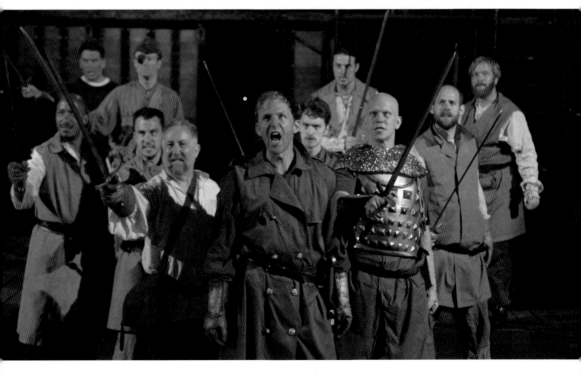

Philander Barclay (1878–1940)

Oak Park's self-styled village historian died penniless and alone from a self-inflicted drug overdose in the Morrison Hotel in the Loop. Barclay loved Oak Park too much to kill himself there. He was a loner, never a joiner. He knew hundreds of villagers by name yet had no intimate friends. He was known as "Bicycle Barclay" because he was a bike repairman during the widespread bicycling craze of the early 1900s. When the bicycle fad came to an abrupt halt, as automobiles became more affordable, Barclay's bike shop failed miserably. From then on, he was unable to find steady employment. While only in his 20s, he had a strong sense of preserving history and became Oak Park's unofficial photograph historian. He biked around the village photographing streets, buildings, railroads, and people with his Kodak box camera. The pedometer on his 1899 Columbia bicycle—on permanent display at the Historical Society of Oak Park and River Forest—registers 4,291 miles of pedaling. The 1902 Barclay photograph shows members of Oak Park's Mount Carmel Colored Baptist Church, many of whom worked as domestics

and railroad porters. Barclay wrestled with lots of demons. He was an insomniac who was addicted to barbiturate sleeping powders and other sedatives that were easy to come by at the time, particularly if one's dad were a druggist, as was Barclay's. He experienced multiple episodes of drug overdosing that required hospitalization. He often roamed the streets all night until the sun came up. When he committed suicide at 62, he left behind over 1,000 photographs, which are also in the historical society's collection. Barclay's work helps transport present-day Oak Parkers to the turn of the 20th century. Three popular Oak Park restaurants—Philander's, Poor Phil's, and Barclay's—have been named for him.

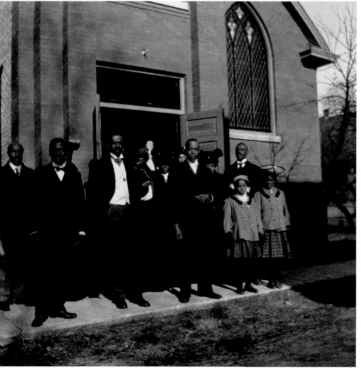

David and Sandra Sokol

The couple embodies the qualities of commitment, volunteerism, and community that have become the hallmark of late-20th-century Oak Park. New York City natives David (born in 1941) and Sandra (born in 1942) and their two young sons arrived in 1972. They chose the community for its reputation of fostering diversity and for its quality education. While some whites were fleeing at this time, the Sokols purchased their home in east Oak Park despite warnings against moving into a racially changing neighborhood. Though the former elementary teacher was now a stay-at-home mom, Sandra immediately got involved with housing and diversity issues, starting before-and-after-school day care before it became the norm, and fighting the then common real estate practice of redlining. After a decade in the Community Relations Department, Sandra became a beloved village clerk for four terms. David, also a veteran of public service, is a professor emeritus, former museum curator, and chair of the art history department at the University of Illinois at Chicago. Three times, David headed Oak Park's Historical Preservation Commission. He has chaired the village's public art commission, was an Oak Park trustee from 1977 to 1981, and is an elected member of the library board. He is also the author of three books on Oak Park history and a literacy volunteer tutor at the Oak Park Library. The Sokols helped change the name of Hawthorne School, located 416 South Ridgeland Avenue, to Percy Julian Middle School to honor the Oak Park scientist. David holds the couple's 1963 wedding photograph. (Courtesy of *Wednesday Journal*.)

Elsie Jacobsen (1914–2003)

"You have to tackle all problems with energy and optimism," she always said. Elsie Lunde Jacobsen, Oak Park High class of 1932, gave unselfishly of herself for over six decades. She was full of warmth and wisdom, yet she could also be disarmingly assertive. She herself was personally responsible for drafting many villagers, this writer included, into getting more involved in Oak Park. In the early 1940s, Elsie's dentist husband recognized she was a bored and restless housewife.

"I was spending all my time embroidering place mats to match my china pattern and keeping a file of the allergies of our dinner guests," she later recalled. "Earl advised me to just get off my duff and get involved. Little did he know he was creating a Frankenstein!" Elsie always pushed for positive changes. She was founder and chair of the Oak Park Beautification Commission. She initiated the annual Home & Garden Show, Arbor Day celebrations, and tree plantings at local schools. In the 1960s, she helped found the Historical Society of Oak Park and River Forest while simultaneously launching a citizens committee to celebrate the 100th birthday of Frank Lloyd Wright. This project evolved into the annual Wright Plus House Walk. Elsie helped establish the Frank Lloyd Wright Home & Studio Foundation to save the historic property from the wrecking ball. She next launched the "Save the Garfield Conservatory" drive to rescue the 1929 greenhouse. In addition to developing various conservation programs, she also organized and cataloged photographer Philander Barclay's massive collection of 1900s photographs and glass-plate negatives. Elsie shot over 400 new slides to show the same locations "then and now." She frequently shared her slide show with schools and organizations. Elsie was involved with everything from UNICEF to school boards—she was the first woman president of the District 200 Board—and from the Hemingway Foundation to the Oak Park Council on International Affairs, which funds the building of schools in Third World countries. In the 1970s, after a century of no alcohol in Oak Park, when the local prohibition was repealed, it was Elsie who was served the first legal drink at Philander's, a new restaurant created in the ballroom of the Carleton Hotel. Wearing early-1900s costumes in the photograph taken that night are, from left to right, (first row) Elsie Jacobson and, dressed as Philander Barclay, Lyman Shepherd; (second row) restaurant owner Dennis Murphy and historical society president Warren Stevens.

Mel Wilson and Nathan Linsk

They were married in the Superior Court of the District of Columbia on August 23, 2010. Along with a few others, longtime partners Mel Wilson (right, born in 1942) and Nathan Linsk (born in 1950) were founders of the Oak Park Area Lesbian and Gay Association (OPALGA) in 1989. The first political action of the organization was to interview candidates for village trustee on their position of including sexual orientation in Oak Park's nondiscrimination statement. The candidates they supported were elected and passed the inclusion. From there, Wilson and Linsk led OPALGA in pushing Oak Park trustees to create a domestic partnership ordinance for gays and lesbians. They were also instrumental in motivating both Oak Park boards of education to include sexual orientation in their nondiscrimination policies. The couple helped institute sexual orientation workshops for the faculty at the high school, worked with Parents and Friends of Lesbians and Gays (PFLAG), and supported lesbians and gay men who were parents themselves. Wilson and Linsk have both served as officers in OPALGA and continue their strong interest and deep involvement in the organization. (Courtesy of Mel Wilson.)

Barbara Ballinger

Oklahoma native Barbara Ballinger (born in 1925) was a sociology major whose previous job had been driving a bookmobile all around Kansas City. Oak Park Library's rich history was already established when Ballinger arrived in the 1950s. But the village at mid-century was certainly not as open-minded, diverse, laid back, or welcoming as it would become in the next decades. Native son Ernest Hemingway's novels, still considered morally impertinent despite his Nobel Prize, were kept behind the library desk and required special approval before they could be checked out. Following her stint as head of Oak Park's Maze Branch, Ballinger became head librarian at the main library in 1967, a position she held for the next 24 years. The library and its usage boomed phenomenally under her leadership during a busy and rather challenging period of Oak Park history. In retirement, she has remained an avid supporter of the community's rich cultural life and became deeply involved with the Hemingway Foundation. A popular community lecture series funded by the Friends of the Oak Park Public Library is named for Ballinger. She (left) poses with award-winning author of 14 novels Louise Erdich at a 2012 lecture. (Courtesy of Debby Preiser)

John Gearen (1914–1993)

He was a quiet leader who served as village president from 1969 to 1973. Serving three times on the village board, "Jack" Gearen was a fair housing proponent. Gearen put in two terms as trustee during the insecure 1960s when the adjacent West Side of Chicago was rapidly resegregating or racially changing from white to black. There were explosive public hearings at the high school that turned into shouting matches. Gearen and other board members who supported open housing were harassed and received death threats. The police had to protect their homes. Gearen even endured public protests staged on his front lawn. Many insecure Oak Parkers were scared into thinking that an open housing policy would create social havoc by accelerating racial shift in the community.

But Gearen bravely stood his ground; though the board was divided on the topic, Oak Park's landmark fair housing ordinance passed in 1968. People still recall how Gearen always chose to see the best in people. He had considerable personal warmth and offered calm, cool leadership. Ever courteous, no matter what folks had to say to him, he became a role model for people in Oak Park government. In a very heated campaign, Gearen became village president, defeating two candidates who had strongly opposed the fair housing statute. His election turned the corner for the community and empowered the village to be more forward-thinking and progressive. He led a drive to construct a new village hall in east central Oak Park, a zone that was often perceived as threatened by the adjacent West Side.

Mary Wessels (1855–1916)

At 42, Mary Wessels was the "spinster nurse" in charge of a local boys' orphanage that burned to the ground in 1897. All 30 of the boys were rescued and farmed out to welcoming families in the middle of the night. But before she could find another position, a struggling woman who had been abandoned by her abusive drunkard husband brought brothers, ages six and seven, to her door. To help the frantic mother get on her own feet by working in a Lake Street laundry, Wessels agreed to temporarily take in both youngsters. But "Ma Wessels," as she came to be called, was so good at tending children that soon her small clapboard cottage on Maple Avenue was chock full of kids sleeping on folding cots and in makeshift fruit crate "baby beds." Her dining room was converted over into a dormitory for older kids. There was such a steep stigma attached to women who worked that their children were referred to

as "half orphans." Mothers forced to take jobs by adversity had nowhere to board their kids. Wessels became an outspoken advocate of helping women become self-supporting rather than public charges. Wessels struggled single-handedly with her goal of "trying to rebuild broken families." She accepted both boys and girls so that siblings could be kept together. Wessels called her place Hephzibah Home, borrowing her own mother's biblical first name, which means "comforting mother." She liked to point out that the three *H*s in the name stood for health, happiness, and harmony. As she struggled along independently, neighbors and church groups came to her rescue. John Farson, Henry Austin, and other local movers and shakers became the founders of the Hephzibah Home Association. Wessels's mission to "care for society's most vulnerable children," especially orphans and foster children, continued after her death. In 1929, Hephzibah Home moved to its present location at 946 North Boulevard. Today, Hephzibah continues to develop new programs to meet the changing needs of the community and the many youngsters it serves. (Both, courtesy of Hephzibah Home Association.)

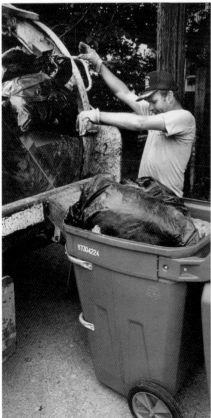

Mike Clark

His many friends have dubbed him the village's unofficial mayor. Lots of folks in Oak Park know Mike Clark (born in 1955). People see him walking all over, greeting everyone along the way. Though Mike has a developmental disability, it has certainly never affected his social skills. He is a much beloved community member who many say "brightens all our days." After finishing his special needs school program, Mike achieved his lifelong dream of becoming a garbage man. But when the village tried to restructure their garbage collection process due to budget cutbacks, Mike was bumped from his job. He then seemed to lose his sense of importance. But his many friends, angered by his layoff, came to Mike's defense. Scores of letters of support poured in to the local newspapers, and thousands of villagers signed a petition to save his job. Ultimately, Oak Park was able to keep Mike employed. As a guy well known for his friendly wave and big smile, he enjoys almost celebrity status. He lives independently at the Oak Park Arms and is especially well known on the Oak Park Avenue business strip. He is seen with one of his buddies, Lauren Woelfly, at Winberie's Restaurant, 151 North Oak Park Avenue. Mike is an avid supporter of Little League teams, Oak Park hockey, and girls' lacrosse games, as well as being a fixture at Circle Lanes' bowling leagues. (Both, courtesy of *Wednesday Journal*.)

CHAPTER TWO

Art and Culture

The Oak Park cultural scene has long been vibrant. Beginning in the 1880s, a popular orchestra gave frequent outdoor concerts. Artists painted along the Des Plaines River. By the turn of the 20th century, a fine arts society that hosted frequent exhibitions was formed with architect Charles E. White (1876–1936) and sculptor Richard Bock (1865–1949) as officers. The membership was made up of village artists, authors, and musicians.

Oak Park is an outdoor museum of architectural history—the world's largest collection of Prairie School buildings. The extraordinary range of architecture illustrates Oak Park's evolution from rural village to urban suburb.

The Warrington Opera House, designed by popular Oak Park architect E.E. Roberts, opened in 1902 at 104 South Marion Street. The state-of-the-art theater, which could seat 1,500 people, was used by local performers for choral concerts or minstrel shows and by stock companies until talkies and the Great Depression forced it to go dark. The banquet hall that later occupied the former theater shut down in 2001, and the building was razed to make way for a condo building.

In 1982, Randall Kryn, director of the Oak Park Center of Creativity, observed: "Most people who read the list of talented innovators from Oak Park have to remind themselves several times that it is a list from one 4.6-square-mile area and not an entire state or region."

Charles Clarahan, for instance, was one of the designers of the Golden Gate Bridge in San Francisco. Vida Brown Olinic and Helene Alexopoulos were both prominent ballerinas.

Gladys Welge (1902–1976), a child prodigy violinist, opened her own school of music while still a teenager. In 1931, when it was thought women lacked the stamina to conduct, Gladys was the founding conductor of the Oak Park and River Forest Symphony Orchestra.

Freelance illustrator, comic book artist, and cartoonist Archer Prewit (born in 1963) is also a bass player who cofounded The Cocktails band. Recently, he has been playing with Sea and Cake.

Oak Park has a long list of resident writers. Mignon Eberhart (1899–1996), "America's Agatha Christie," was an Oak Park librarian when she published her first best seller, *The Patient in Room 18*, in 1929. Eberhart, who published her last novel at 88, wrote 59 books. Richard Bach (born in 1936) was the author of the hugely popular best seller *Jonathan Livingston Seagull* in 1970.

Most art collectors share their treasures with only a select group, but not Joseph Shapiro (1905–1996), who arrived from Russia at age two with his immigrant parents. His Oak Park home, a veritable art museum, was open to any school group or organization that simply called ahead. Shapiro's collection included works by Chagall, Kandinsky, Miró, Dalí, Klee, and Magritte. A giant in the popularization of modern art, Shapiro founded the Museum of Contemporary Art in 1967.

Joseph Shapiro often said, "You don't learn and grow unless you take chances and risks."

The 33 artists in this chapter—from the fields of photography, painting, dance, literature, architecture, music, and fashion—were never strangers to risk-taking.

Ernest Hemingway (1899–1961)

Oak Parkers have long taken umbrage at his reported description of their village as a place of "broad lawns and narrow minds," which pegged the community as having both privilege and intellectual simplicity. Yet no one has ever been able to conclusively pin that disparaging quote to Ernest Hemingway. The celebrated author was born in his paternal grandfather's Queen Anne–style Victorian home. After showing early promise as a writer at Oak Park High, Hemingway became one of the expatriate artists of the Lost Generation living in Paris in the 1920s. Always a larger-than-life figure, he glorified such heroic male exploits as boxing, bullfighting, and deep-sea fishing in his novels. Hemingway's understated, economical style was a major influence on American fiction writing. His revolutionary use of sparse, journalistic prose caused him to be emulated by generations of writers. He won both the Pulitzer Prize and the Nobel Prize for Literature. Like his father and two siblings, Hemingway took his own life. Though he wrote many novels and short stories, Oak Park never appeared in any of Hemingway's fiction.

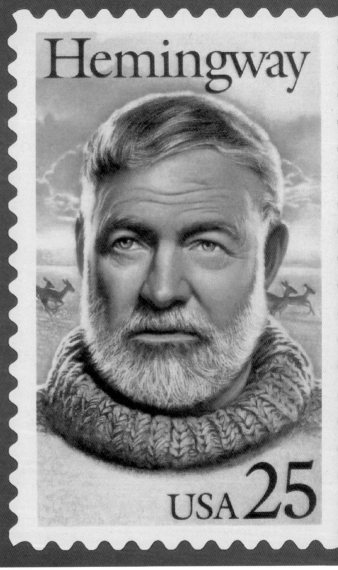

Hemingway

USA 25

Grace and Dr. Clarence Hemingway
Actors Sara Minton and Kevin Bry portrayed Ernest Hemingway's parents in a 2010 Hemingway Birth Home tour. (Courtesy of Debby Preiser.)

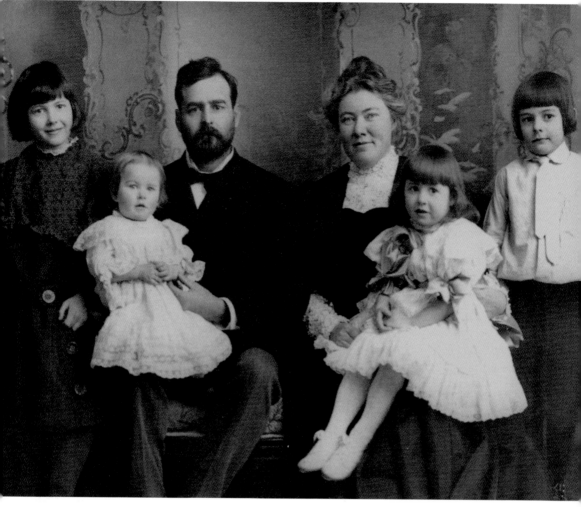

Grace Hall Hemingway (1872–1951)

She was talented, fiercely independent, and dynamic. Novelist Ernest Hemingway always credited his father, Dr. Clarence Hemingway, for providing a strong influence, cultivating in him his love for hunting, fishing, and nature. But his mother, Grace Hall Hemingway, nurtured both his artistic sense and his strong ego that, like hers, thrived on publicity. Grace had married Clarence, a handsome young doctor and a former Oak Park High classmate, who lived across the street and cared for her dying mother. As a piano and voice teacher, Grace often generated far more income than Clarence's struggling practice. She was a gifted musician who gave up her career as an opera singer to focus on rearing her six children. But Grace hated domestic responsibilities; Dr. Hemingway did much of the cooking and was acclaimed for his pies. She required each of her children to play an instrument; Ernest learned the cello. Her lavish music room was large enough to seat 200 people. (Ernest staged boxing matches there.) She was an active campaigner for women's rights and served on the Illinois Suffrage Commission. Grace was very supportive of any of her children's creative efforts but often disapproved of Ernest's subject matter. In 1906, Grace is seen with her husband, Clarence, and the four eldest of their six children—Marcelline; Madelaine "Sunny," on her dad's knee; Ursula, on Grace's lap; and Ernest. After her husband's suicide in 1928, Grace began a new chapter in her life as an accomplished artist, known for her landscapes and still lifes.

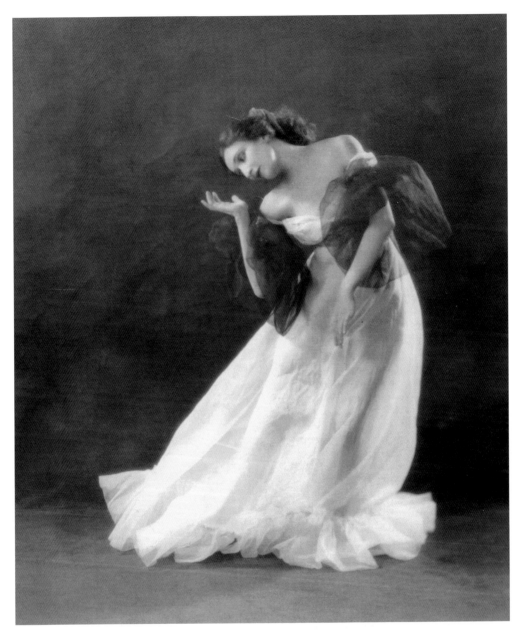

Doris Humphrey (1895–1958)

Born to a prominent Oak Park family, Doris Humphrey was an energetic, creative child who began teaching dance in 1913 at Unity House, adjacent to Frank Lloyd Wright's Unity Temple, at age 18. Her mother played the piano for her dance classes while Doris provided instruction for Oak Parkers seeking to learn the latest fad "animal steps," like the turkey trot, the bunny hug, the grizzly bear, and the fox-trot. In her 20s, she became an internationally known performer and choreographer who helped pioneer the art of modern dance. Her movement idiom represented a radical break from classical ballet. She was also able to communicate her principles in a simple way. Doris explored the expression of the human body rather than the colorful but superficial dances. Her dances and theories are still taught, studied, and performed a century after her career began.

Stephanie Clemens

Born in 1941, Stephanie Clemens is a celebrated dancer and teacher, known internationally for her dedication to the preservation of historical modern dance, especially the work of Doris Humphrey. Clemens is director of Oak Park's Academy of Movement & Music (615 Lake Street), a school for the performing arts from preschool through adult, and Momenta, a dance troupe. She restored a section of the old Bishop Quarter Military Academy as her school in 1983. Trained in ballet at the Julliard School of Music, Stephanie studied with many luminaries in modern dance. In 1977, she created the Tidmarsh Arts Foundation, the fundraising and grant-giving arm of the Academy of Movement & Music. Tidmarsh, which works to raise funds to help deserving students in need of financial support, is named in honor of her mother, Ruth Miller Tidmarsh, an artist, teacher, and lifelong patron of the arts. Clemens, who holds a degree in Physical Anthropology from University of California, Los Angeles, coedited a text called *Adam or Ape* with anthropologist Dr. Louis B. Leakey.

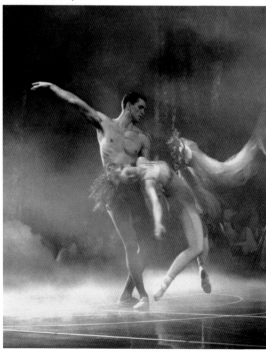

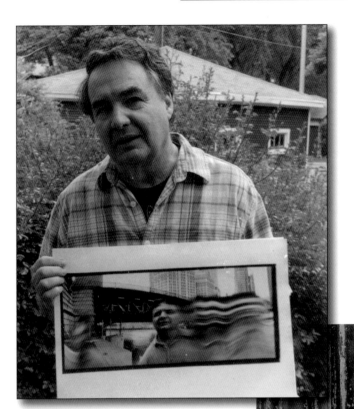

Tom Palazzolo

Born in 1937, Tom Palazzolo attended grad
school for painting and photography at
the School of the Art Institute of Chicago.
Avant-garde filmmaker Palazzolo admits he
did not know how to even operate a movie
camera until 1964, when he was 27. In the
mid-1960s, he began making a number of
experimental films, mostly humorous and
insightful, all of which capture the rich social
and political fabric of the period. Palazzolo's
early works, surrealist and quirky cinema
verité, celebrate distinctive Chicago subjects
and imagery, from antiwar protests to senior
citizen picnics and from a tattooed lady in
the Freak Show of Riverview Amusement
Park to colorful merchants at the Maxwell
Street market. Swept up in the new art form
known as Chicago Underground Film, he
seemed drawn to the freaks and outcasts
of society. "We were doing our own thing,"
Tom remembers with pride. He has always
disliked the commercial filmmaking culture
of Hollywood. Tom's wife, Marcia Palazzolo,
is an accomplished artist and photographer.
(Both, courtesy of Tom Palazzolo)

Edgar Rice Burroughs (1875–1950)

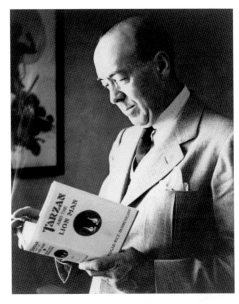

His plots were often blurry, his characters were one-dimensional, there was too much contrivance and coincidence, and his endings were abrupt. But the 67 books written by Edgar Rice Burroughs were so enormously popular that they were translated into 26 languages. Burroughs came from a prosperous background but failed at everything he attempted—from cowboy to gold miner. He even tried selling lightbulbs and pencil sharpeners door-to-door. He seemed unable to support himself, let alone his family. While Hemingway wrote early and often, Burroughs never penned a line until he was 36. After pawning the last of his wife's jewelry to buy groceries in 1911, Burroughs desperately wrote a fantasy tale about a man transported to Mars. *All-Story* magazine purchased this early science-fiction story for $400. Next, although he had never set foot in Africa, Burroughs published in 1912 a story about an aristocratic child raised by African apes. He was paid $700 for *Tarzan of the Apes*. (The name Tarzan was explained as ape-talk for "white skin.") The book led to a multimillion-dollar empire and dozens of movies. Though his 26 Tarzan books are chiefly responsible for Burroughs's popularity and reputation, he also completed popular Westerns and science-fiction books. He wrote each one in longhand with no planning or preliminary outlining. Rarely doing any revision or polishing, he finished each one in a month or less. During World War I, as a major in the Illinois Reserves, Burroughs was such a staunch patriot that he refused to allow his publisher to translate any of his books to German. He aggressively cross-marketed the Tarzan brand, a rarity in his day, by creating movies, comic books, lunch boxes, and lots of other merchandise bearing the jungle hero's image. Olympic swimmer Johnny Weissmuller, perhaps the best-remembered Tarzan, played the role in 12 films in the 1930s and 1940s.

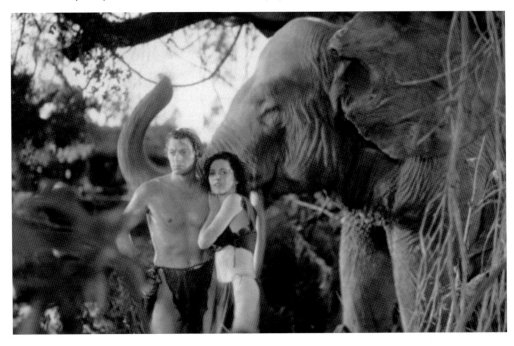

Bruce Davidson

One of the best-known photographers in America had a very devoted single mother. Born in 1933, Bruce Davidson cultivated his love of photography at the age of 10 when his mom built him a basement darkroom. In 1947, at the age of 14, Davidson won his first prize in the Kodak National High School competition. After military service, he worked as a freelance photographer for *Life* magazine. His photographs were often praised for their "poetic mood." As a result of his chronicling the events of the civil rights movement, Davidson received the first-ever photography grant from the National Endowment of the Arts. He is seen with his daughters.

Charles MacArthur (1895–1956)

In 1911, when Charles MacArthur (left) was 16, his family moved into Frank Lloyd Wright's home when the architect converted the property into rental units and ducked out of his marriage. Young MacArthur began his journalism career as a reporter with the village newspaper, the *Oak Leaves*. One of his assignments involved disguising himself as a hobo and sleeping with other homeless transients at the Oak Park Police Station on subzero nights. He worked at both the *Chicago Herald-Examiner* and the *Chicago Tribune*. He used much of his press experience as background when he and fellow reporter Ben Hecht (right) wrote their fast-talking newspaper comedy, *The Front Page*, which made it to the screen three times. The 1940 screwball comedy version, *His Girl Friday*, stars Cary Grant and Rosalind Russell. Hecht and MacArthur were a screenwriting team that cranked out such successful 1930s movie scripts as *Gunga Din*, *Barbary Coast*, and *Wuthering Heights*. MacArthur dated writer Dorothy Parker but, in 1928, married Helen Hayes, known as the "First Lady of the American Theater."

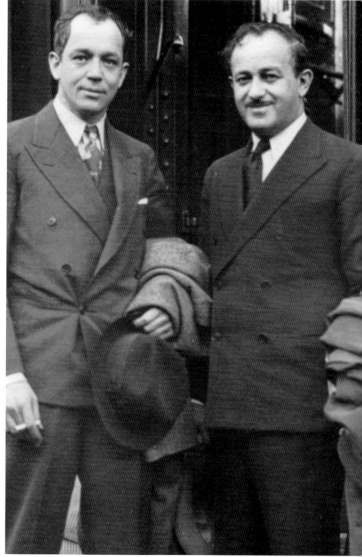

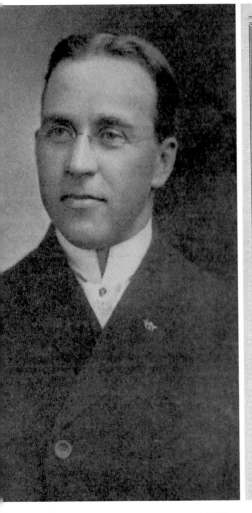

Seward Gunderson (1866–1950)

In the early 1900s, he demanded quality and craftsmanship in the homes that bore his name in his new subdivision south of Madison Street. They were nothing fancy—just very well built. Seward Gunderson brought craftsmen from Norway to build his houses and was incredibly demanding. When he discovered one of his contractors had mislaid a steel post by three inches, Gunderson gave him exactly two hours to jack the house up and place it properly. While much of south central Oak Park was still a vast prairie, he filled up his Gunderson Subdivision with houses known for their durability and sturdiness. They were never considered innovative or avant-garde, like those of Frank Lloyd Wright and the Prairie School architects. But they were solid, aesthetically pleasing, comfortable, and affordable. They were priced between $4,500 and $7,500. S.T. Gunderson & Sons offered 42 distinctive models with 14 different floor plans. Each home had oak floors, six closets, art-glass windows, sliding pocket doors separating the parlor from the dining room, bay windows, and a solid oak sideboard in the dining room. Most of his homes also had screened-in back verandas called sleeping porches, popular in the era before air-conditioning. Gunderson pioneered many construction techniques, including steel beam supports and concrete block basement foundations. He was also instrumental in having the metropolitan elevated (now the Blue Line) extended into Oak Park, adjacent to his housing development. For decades, the station was located at Gunderson Avenue, which was named for him.

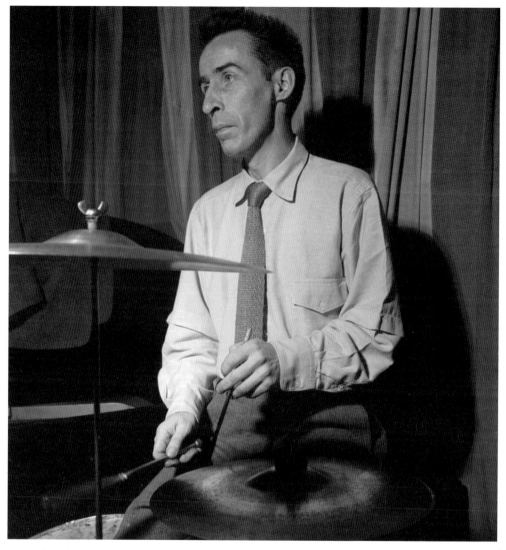

Dave Tough (1907–1948)

Drummer Dave Tough (aka David Jarvis) played a key role in the development of what came to be called the "Chicago Jazz" style. A frail, often forlorn-looking little drummer, Tough lacked star quality or stage charisma. Unlike Gene Krupa, he was never a frenetic showman and hated to solo. But in poll after poll, musicians always voted him their favorite—"the greatest drummer of the 20th century." Tough's father, a prominent physician, did not approve of his son's career path. The teen spent hours studying "race records," early black jazz recordings marketed in African American neighborhoods. At 16, Tough would sneak to South Side clubs and dance halls that most whites did not know existed. He married Casey Majors, a black cabaret dancer. Tough played with most of the major swing bands, including those of Tommy Dorsey, Benny Goodman, Bunny Berigan, Jack Teagarden, and Woody Herman. During World War II, he toured the Pacific war zone with Artie Shaw's Navy Band. But Tough had his demons. He was a deeply troubled alcoholic who sometimes suffered fits and would burst into tears on the bandstand. He became a street derelict, begging for handouts. Tough died at 40 from a skull fracture caused by a drunken fall.

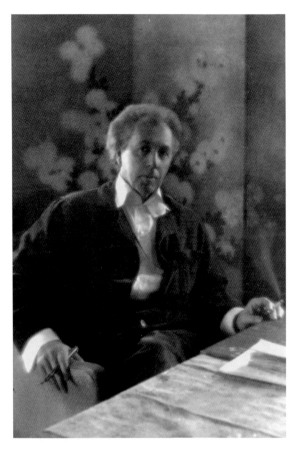

Frank Lloyd Wright (1867–1959)

He was an arrogant narcissist with frequent money problems due to his financial mantra: "Take care of the luxuries and the necessities will take care of themselves." Frank Lloyd Wright was also a genius who worked at his craft from age 18 until his death at 92. He won world recognition for his revolutionary architecture: broad, low houses, with flowing interior spaces lit through long expanses of glass. This radical new American style of architecture, later dubbed the Prairie School, bore little resemblance to the tall historical-revival models prized by the Victorians. Harmony was his architectural idea, but he had little of it in his debt-ridden, scandal-plagued private life. In his early 40s, Wright left his wife, Catherine, and his six children with a pile of bills to run off with Mamah Cheney, the wife of one of his clients. Oak Parkers were furious with him for generations, yet the community boasts the largest concentration of Wright-designed buildings in the world. Hundreds of tourists visit the Wright Home & Studio every week.

Anne Baxter (1923–1985)

Frank Lloyd Wright's granddaughter Oscar-winning actress Anne Baxter never lived in Oak Park. But in the 1970s, she became deeply involved in the restoration of the Wright Home & Studio. Besides lending her name and insights, Baxter generously provided heirloom Wright family furnishings, including a wooden baby cradle that was used by all six offspring of the architect. Baxter is buried on the estate of Frank Lloyd Wright in Spring Green, Wisconsin. She is seen in the title role of *All About Eve* (1950).

John Wright (1892–1972)

Pictured in 1897 at age five, the second son of architect Frank Lloyd Wright followed his famous father into architecture by assisting him in large-scale commissions, most notably Tokyo's Imperial Hotel. But John Wright had conflicts with his dad, especially when the famous architect refused to provide a steady salary or tried to pay him with Japanese prints. John struggled to become independent and ultimately launched his own practice after being fired by his father. But he is best remembered not for any of his design work but as the 24-year-old inventor of Lincoln Logs, the interlocking children's building blocks. They were an instant success in 1916, challenging kids' powers of concentration and eye-hand coordination.

Agnes Newton Keith (1901–1980)

Agnes Newton Keith's father, Charles Newton, was one of the founders of Del Monte Foods. She was the author of seven books about her life with her husband and family in Southeast Asia before and during World War II. She is best remembered for *Three Came Back*, a harrowing account of her time in a Japanese prisoner-of-war camp in occupied North Borneo. The autobiographical best seller details the deprivation and dangers of her internment with her small son. Keith's story of courageous survival was made into a 1950 movie; Claudette Colbert portrays her. Sessue Hayakawa plays the cruel camp commandant, Colonel Suga. The film, in which Keith makes an uncredited cameo, mentions her Oak Park background.

Carl Kraft (1884–1938)

Though he was once a nationally known, award-winning landscape painter, his name is now virtually forgotten. But in 1921, Carl Kraft and several other local artists formed the Oak Park Art League, an organization that still thrives in Oak Park. After Catherine Wright, the estranged wife of Frank Lloyd Wright, left the community, the new arts group rented the architect's studio for its classes and programs. Members sketched and painted under the gingko tree in the courtyard. In 1937, the Oak Park Art League acquired a Victorian carriage house at 720 Chicago Avenue, which was then renovated by architect E.E. Roberts. It is still the group's home. Members continue to promote the arts with exhibits, programs, and courses. Kraft, who exhibited his works in prestigious galleries across America, also ran a popular restaurant called The Round Table, at 727 Lake Street. Kraft's 1920s oil painting *Ozark Spring* hangs in the Historical Society of Oak Park and River Forest.

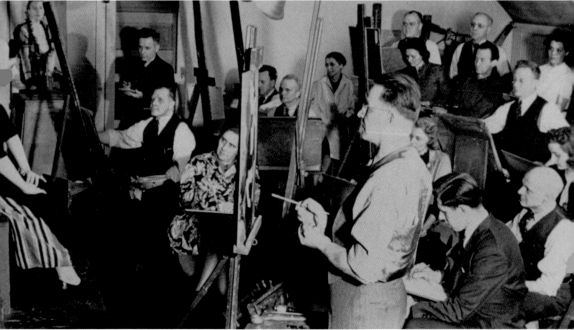

E.E. Roberts (1866–1943)

Though they were contemporaries and neighbors whose children were playmates, Ethan Ezra Roberts and Frank Lloyd Wright were competitors, never friends. In fact, Wright was said to have only disparaging remarks for Roberts's work. The more popular E.E. Roberts was the most widely represented architect in Oak Park. He broke no new ground in terms of design, yet he had the largest, busiest architectural office in the community. His Oak Park buildings number in the hundreds. Though he specialized in residential design, his massive output included such well-known structures as the Warrington Opera House; West Suburban Hospital; Euclid Avenue Methodist Church; the Maze Branch Library; the original village hall; Lincoln, Irving, and Whittier elementary schools; and portions of Oak Park High School. The Playhouse at 1113 South Boulevard was a state-of-the-art 1913 silent movie house with a retractable glass roof, which allowed the auditorium to cool naturally on hot summer nights.

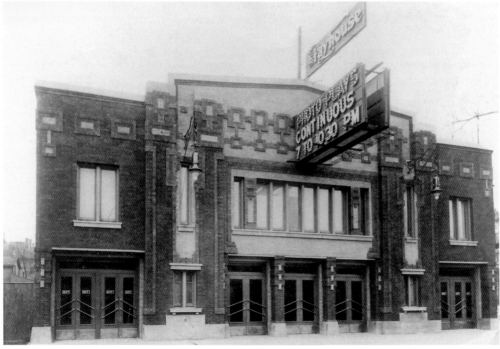

Adolph "Bud" Herseth (1921–2013)

Widely regarded as the greatest symphonic trumpet player of all time, Adolph Herseth joined the Chicago Symphony Orchestra (CSO) in 1948. He was the principal trumpeter of the CSO for an unprecedented 53 years. "Bud" Herseth is well known for both his dazzling talent and his career longevity. He began playing trumpet at age seven; a year later, he was playing in his father's band. Herseth and his wife moved to Oak Park after World War II. He was always proud of selling the community to other members of the CSO, many of whom moved to Oak Park as a result of his boosterism.

Charles Simic

During World War II, when he was a child in Belgrade, Charles Simic (born in 1938) and his family were forced to evacuate their home several times during heavy bombing. After the war, they migrated from Yugoslavia and settled in Oak Park. Charles became an essayist and translator, but it was his poetry that attracted the most attention. He won numerous awards, including the Pulitzer Prize for his 1990 work *The World Doesn't End*. Simic, who has published 20-some collections of poetry, was appointed the 15th Poet Laureate Consultant in Poetry from 2007–2008.

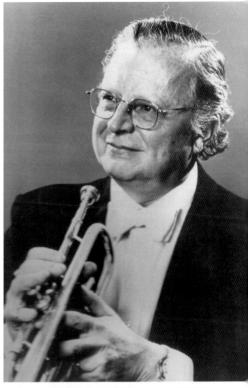

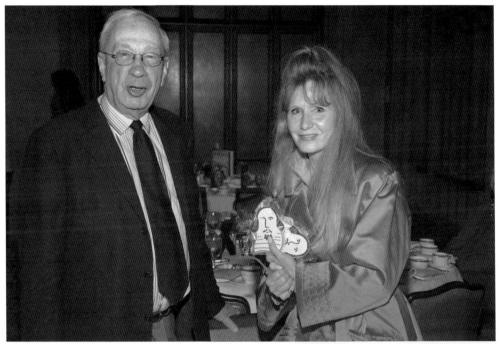

Richard Christiansen

Richard Christiansen (born in 1931) dabbled in acting
at Oak Park High, but the "Godfather of Chicago
Theater" later admitted he had no talent for acting
whatsoever. In the 1950s, drama critic Christiansen
first worked the night shift as rewrite editor on the
Chicago Daily News, where he learned to write fast and
thrived on impossibly short deadlines. In that period,
there were numerous newspapers with multiple
editions. Christiansen covered fires and accidents and
even wrote obits before he became entertainment
editor and "critic-at-large." When the *Daily News*
folded in 1978, he jumped to the *Chicago Tribune*. When
a Chicago theatrical renaissance kicked in, he rallied
appreciative audiences to visit evolving new companies
like Steppenwolf and Victory Gardens. Christiansen
celebrated exciting new artists and writers. Not all
his reviews were favorable, but they were always
constructive. He was the leading voice in Chicago
theater for over four decades. In the photograph, he
is receiving a 2007 Public Humanities Award from
Donna La Pietra.

Carol Shields (1935–2003)

She won the Pulitzer Prize for Fiction. Carol Warner
Shields is best known for her 1993 novel *The Stone
Diaries*, a fictional autobiography of a woman whose life
is marked by death and loss.

Tavi Gevinson

Born in 1996, she began blogging at 11 and was feted by the fashion industry at 12. At 13, Tavi Gevinson rose to fame with her cutting-edge fashion blog *Style Rookie*, which had 50,000 readers a day. She was profiled by the *New Yorker* at 14 and was said to be "on the front line of fashion." When she was a guest on Jimmy Fallon's talk show, he asked, "You grew up outside of Chicago, right?" "I'm *still* growing up outside Chicago," Tavi replied. (Courtesy of *Wednesday Journal*.)

Fr. Andrew Greeley (1928–2013)

A priest, sociologist, journalist, and fiction writer, Andrew Greeley was a professor at the University of Arizona, the University of Illinois, and the University of Chicago. His novels, usually appearing two a year for much of his literary career, include *The Cardinal Sins* (1984) and *Lord of Dance* (1984). *The Priestly Sins* (2004) dealt with the Catholic Church sexual abuse scandal. With the income from his best sellers, Father Greeley funded many philanthropic causes. He fractured his skull when his clothing caught on the door of a taxi as it was pulling away. After a long struggle to recover, Fr. Greeley died from the resulting traumatic brain injury.

Walter Burley Griffin (1878–1931)

Walter Burley Griffin initially saw himself as a disciple when he worked in the studio of Frank Lloyd Wright, and despite increasing responsibilities and the fact that he oversaw the construction of a number of Wright's significant Prairie-style homes, he was never made partner. When Wright returned from his visit to Japan in 1906, he and Griffin often quarreled about overdue salary and the handling of specific projects. Griffin fell in love with Wright's sister Maginel but left the firm when she rejected his proposal of marriage. He is credited with an innovative use of reinforced concrete, the carport, and the development of the L-shaped floor plan. He met Marion Mahoney as a coworker in Wright's office and married her. She was considered his equal. The husband-wife architectural team designed Canberra, Australia's capital.

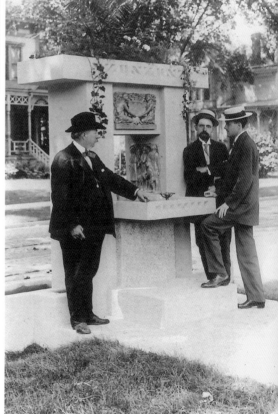

Charles White Jr. (1876–1936)

In 1903, like many other young draftsmen, Charles White got his start locally in Frank Lloyd Wright's architectural studio. Later, on his own, emphasizing a variety of design influences, not just Prairie School architecture, he designed a wide range of Oak Park buildings, including the Cheney mansion (1913) at 220 North Euclid Avenue and the main post office (1936) at 901 Lake Street. He also helped institute the first zoning law in Oak Park. White is the young man in the straw hat on the right in this 1909 photograph by the Horse Show Fountain, now located on the northwest corner of Lake Street and Oak Park Avenue. Charles S. Woodard is on the left; the man in the middle is sculptor Richard Bock.

John Van Bergen (1885–1969)

In 1907, John Van Bergen began his architectural career as an apprentice draftsman with Walter Burley Griffin for $6 a week. Next, he worked in the busy office of E.E. Roberts before joining the team at Frank Lloyd Wright's studio in 1909. He completed the working drawings as well as supervised both the well-known Robie House in Hyde Park and the Laura Gale house in Oak Park. He designed other Prairie-style homes in the area, but in a town dominated by the legacy of Frank Lloyd Wright, Van Bergen was often overlooked.

Mary Agnes Yerkes (1886–1989)

She was a passionate, independent Oak Park native. Mary Agnes Yerkes, an Impressionist painter, worked into her late 90s and died at 103. In 1912, her mother commissioned John Van Bergen, a former Frank Lloyd Wright draftsman, to design a Prairie-style house for the family. The home was specially equipped with an upstairs art studio for Mary. (Courtesy of the Illinois Women Artists Project.)

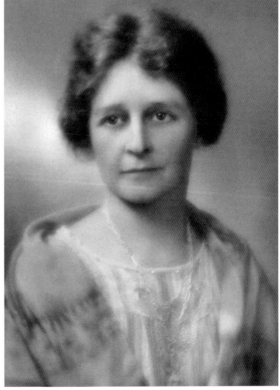

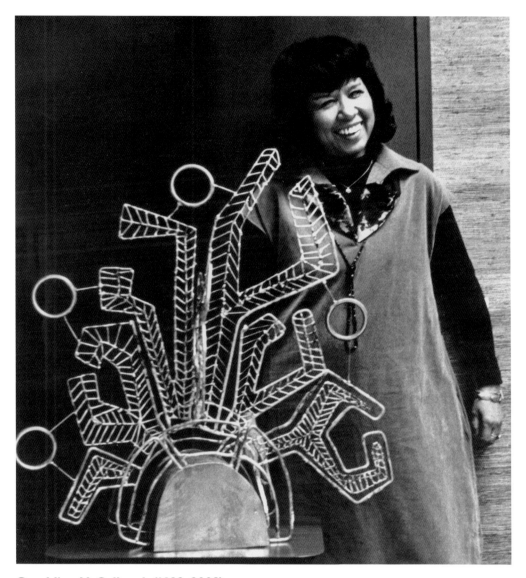

Geraldine McCullough (1922–2008)

Though she initially set out to be a painter, Geraldine McCullough began to experiment with welding. Her husband, Lester, a professional welder, taught her how to use heavy welding equipment. "That was the moment I knew I'd found my niche," she often said. The nationally acclaimed sculptor won prizes and honors, was featured in national magazines, and was part of a coalition of African American artists invited to visit the Soviet Union. McCullough's studio was in a large three-story former Chicago Transit Authority generating station from 1903, which had stood empty for decades. It was the size of a football field because it once housed the massive dynamos that ran the West Side streetcars. Geraldine and Lester converted and renovated the boarded-up building themselves. It made a perfect combination home and studio. "Most of my pieces are so large they often weigh several thousand pounds," she explained, "but with the loading dock on the back of this building, they can be moved easily." McCullough's work can be seen in many locations, such as *The Spirit of DuSable* at the DuSable Museum of African American History or her 13-foot-high sculpture *Pathfinder* in the courtyard of the Oak Park Village Hall at 123 Madison Street.

John La Montaine (1920–2013)

Pianist and celebrated mid-century composer John La Montaine showed early promise as a teen, performing often in Oak Park in the 1930s. His musical career had many highlights. He was the recipient of two Guggenheim Fellowships. As a conductor, he directed the original production of Menotti's *The Consul*. During the 1950s, he was a pianist with the NBC Symphony Orchestra under the direction of Arturo Toscanini. In 1959, La Montaine received the Pulitzer Prize for his *Concerto for Piano and Orchestra, Opus 9: In Time of War*, which had been commissioned by the Ford Foundation. He was commissioned to compose a special overture for John F. Kennedy's inauguration, titled *From Sea to Shining Sea*, which was performed by the National Symphony. La Montaine's bicentennial opera, *Be Glad, Then, America* (1976) celebrates the country's 200th birthday.

Jane Hamilton

The youngest of five children, future literary star Jane Hamilton (born in 1957) initially wanted to become a ballerina. She grew up on an Oak Park block populated with 85 children. "Each block was a kind of intentional community run by mothers whose sole purpose was to care for us," the author remembers. Her mother, Ruth Hamilton, was an actress who performed frequently on Oak Park stages. Jane honed her writing skills first with short stories, eventually expanding one of them into the novel *The Book of Ruth* (1994), an Oprah Book Club selection that became an international best seller. Hamilton has written six novels.

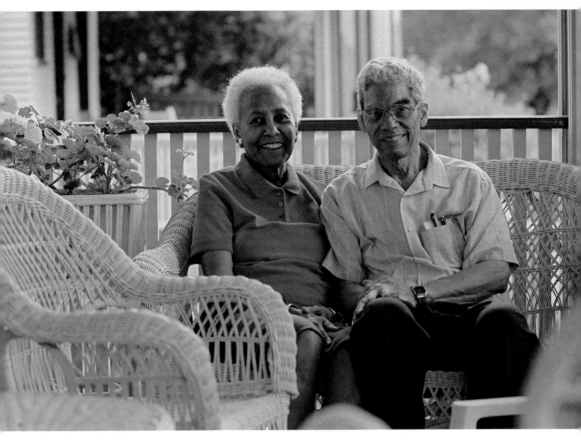

Harriette Robinet

While Harriette Gillem Robinet (born in 1931) was raising her six children, she admitted, years later, "I wrote to avoid going crazy." But her creative writing actually started during childhood. Her history teacher father had seven-year-old Harriette writing stories on the front porch to keep her busy on summer afternoons. As an African American child growing up in Washington, DC, in the 1930s and 1940s, Harriette was not allowed to have a library card. But she read all the classics, supplied by an aunt from her own collection. Holding degrees in both bacteriology and microbiology, she moved with her college professor husband, MacLouis Robinet, and their children to Oak Park in 1965. At that time, realtors avoided dealing with African Americans. But some white friends, a Presbyterian minister and his wife, agreed to act as straw buyers for the Robinets. As one of the first black families to move into the village before the fair housing ordinance, they arrived midday, midweek, to avoid the anxious weekend crowds that congregated whenever an African American family moved in. Harriette and MacLouis had never actually seen the home they had purchased until that afternoon. Deliverymen would ask Harriette for "the lady of the house." Children would stop playing and follow their car when the family drove down the street. But the Robinets made friends and planted roots. They fought discrimination through local civil rights marches and nonviolent protests. When Harriette's son Jonathan was struck with cerebral palsy, she wrote her first book, *Jay and the Marigolds* (1976). At the time, handicapped children were absent from children's literature. Since then, Robinet has written many other juvenile books, primarily historical fiction.

Alex Kotlowitz

Award-winning journalist and best-selling nonfiction author Alex Kotlowitz (born in 1955) has won multiple awards and widespread critical praise for *There Are No Children Here: Two Boys Growing Up in the Other America* (1991). The true story of two young brothers living in a public housing project, it became a made-for-television movie featuring Oprah Winfrey. His other works, such as *The Other Side of the River* and *Never a City So Real*, explore the effects of race and poverty. Kotlowitz's most recent project, *The Interrupters*, a documentary film about the persistence of urban violence, was called "heroically life-affirming" by *Time* magazine. Kotlowitz has contributed to many publications, including the *New York Times Magazine*, *New Yorker*, *Rolling Stone*, the *Atlantic*, the *New Republic*, and public radio's *This American Life*. (Courtesy of Alex Kotlowitz)

Elizabeth Berg

"I was a dramatic and dreaming child," the nurse-turned-best-selling author remembers. "I was living more inside my head than outside, something that persists up to today and makes me a terrible dining partner." Elizabeth Berg, born in 1948, grew up as an army brat whose family moved frequently. She tried a lot of jobs, like waitressing and singing in a rock band. After working as a registered nurse for a decade, Berg wrote freelance nonfiction articles before turning at age 44 to fiction for women about their lives. The American Library Association recognized her 1993 debut novel, *Durable Goods*. Though a few critics have called Berg's novels "sentimental," her books sell in large numbers. Her readers often remark that "reading a book by Elizabeth Berg is like sitting down for a long chat with your best friend." (Courtesy of Debby Preiser)

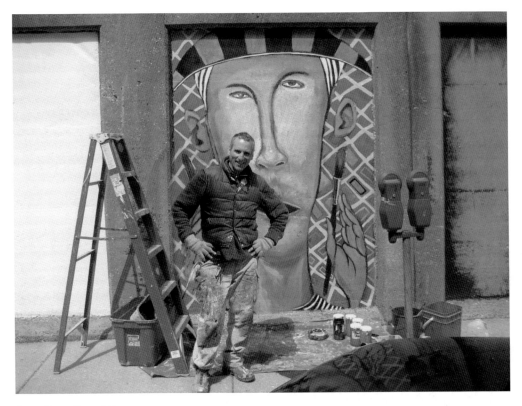

Jonathan Franklin

Born in 1952, he spent much of his time growing up in Vietnam, Bangladesh, and Indonesia while his father was working in Asia as a civil engineer. Jonathan Franklin says *Mad* magazine illustrations influenced his style when he was in his youth. His art education evolved through his worldwide travels. After studying art in college, Jonathan moved to Israel, lived on a kibbutz, served in the Israeli Army, and began working as a printmaker there. As a true Renaissance man, besides being a painter, he is an actor and set designer. The figures in Franklin's paintings often look like actors in a performance. Franklin is seen taking a break from painting one of several large murals on the South Boulevard Green Line elevated embankment.

Chris Ware

The innovative cartoonist, comic book artist, and illustrator, known for his unique lettering, often explores themes of social isolation, emotional torment, and depression. As a child, Chris Ware (born in 1967) was inspired by reading *Peanuts* paperbacks. He drew inspiration from ragtime sheet music and early-1900s advertising. In 1992, he drew a weekly comic strip *Quimby the Mouse* for the free Chicago newspaper *New City*, which later moved to the *Chicago Reader*. Ware's work has appeared in such publications as the *New York Times*, the *New Yorker*, the *Village Voice*, and *Esquire*. His graphic novel, *Jimmy Corrigan, the Smartest Kid On Earth*, was first serialized and then published as a hardcover book in 2000.

CHAPTER THREE

Newsmakers

Oak Park has often dominated the headlines. While the general tone of the suburb is progressive, upbeat, and halcyon, there has rarely been a shortage of conflict and controversy.

The village has seen many local newspapers over the years. One of the earliest, the *Vindicator*, was widely read in the 1880s and 1890s.

There have always been lots of community members who work in the news media, such as Charlie Myerson, radio and Internet journalist who is on WBEZ, and Ed Vincent (born in 1952), who publishes the online *Oak Park Journal*. Hannah Storm (born in 1962), a television sports journalist, was the first female host on CNN *Sports Tonight*. Award-winning television journalist, news anchor, and investigative journalist Bill Kurtis (actually Kuretich, a Croatian name) was an Oak Parker for years.

The community has provided residence for a slew of infamous, headline-grabbing mobsters like Rocco "Rocky" De Grazia (1897–1978), "Machine Gun" Jack McGurn (born Vincenzo Gibaldi) (1902–1936), and alleged St. Valentine's Day Massacre gunman Frank Rio (1895–1935).

Joey Sternaman (1900–1988), the first quarterback for the Chicago Bears, who played on the team for nine seasons, was also a native son.

This chapter showcases 23 Oak Park newsmakers.

Charles Guiteau (1841–1882)

By all accounts, he had not only failed at everything he ever attempted, but Charles Guiteau also was becoming increasingly mentally unstable—perhaps dangerous. After his big flop as a trial lawyer, he tried being an itinerant evangelist preacher but was soon asked to "leave the calling." He was even forcibly ejected from the radical free love commune in Oneida, New York. Next, Guiteau was sued for fraud when his debt collections business collapsed. His wife divorced him, charging extreme cruelty. Before long, Guiteau was thrown into jail for nonpayment of his rent at his rooming house. After his sister Frances bailed him out, he came to Oak Park to live with her. But her schizophrenic brother terrified her; he once threatened her with an axe. For over a year, she tried to get him committed to the Dunning Lunatic Asylum, fearing "something terrible will happen." Convinced James A. Garfield owed him a diplomatic position because he once delivered a self-initiated street corner speech on behalf of the president, Guiteau began to pursue him. Though he was totally lacking in qualifications for such a post, Guiteau so persistently petitioned for an office that he was finally barred from both the White House and the State Department. Increasingly disturbed and agitated, he began to stalk Garfield, eventually following the president to the Washington, DC, railroad station where he shot him twice on July 2, 1881. Garfield lingered, mortally wounded, for 80 days before he finally died. Guiteau was hanged on June 30, 1882. Because of this Oak Park psychopath, there was a drive to abandon the long-standing spoils system, and security surrounding future presidents became tighter and more vigilant.

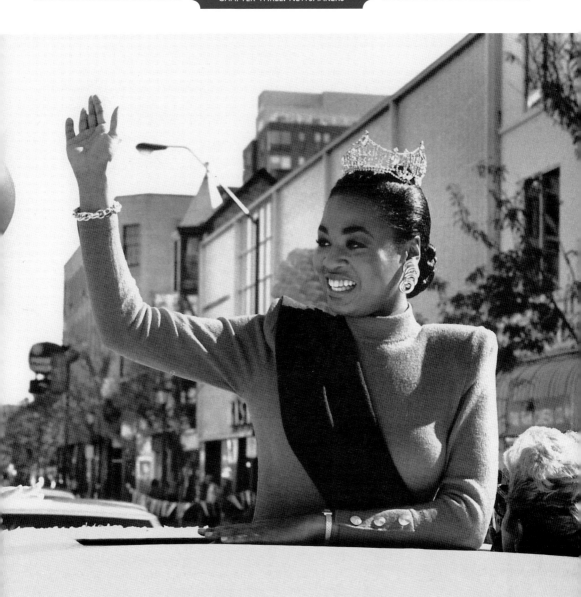

Marjorie Judith Vincent

Born in 1965, she was the fourth black Miss America when she won the title in 1991. Marjorie Judith Vincent came from a close family. Her parents emigrated from Haiti in the 1960s when Marjorie was three. Her father, a doorman at the Hyatt Regency O'Hare, and her mother, a seamstress and caterer, always stressed the importance of education. As a small child, Marjorie became career-oriented. She was an accomplished pianist and was a music major at college until she changed to a pre-law program. She was interning with a major Loop law firm when she won the Miss Illinois Pageant. Marjorie beat 50 other hopefuls for the Miss America title. She knocked out the judges in the talent division with her piano-playing skills, performing the *Fantaisie-Impromptu* by Chopin. During her reign, the 25-year-old chose the prevention of domestic violence as her focus issue. After a career in television, the wife and mother completed her law degree.

Mamah Cheney (1869–1914)
She was an admired, accomplished Oak Park wife and mother who spoke six languages and was a staunch advocate for women's rights. Mamah (pronounced "May-mah") Borthwick Cheney was educated, independent, and one of the first women in the village to drive an automobile. Mamah and Catherine Wright were members of the same club, and with this connection, Mamah persuaded Catherine's architect husband, Frank Lloyd Wright, to design a brick Prairie-style home for her and her husband, Edwin, in 1903. That commission sparked a scandalous love affair, however. Wright shocked Oak Park when he dumped his practice, abandoned his family, and ran off to Europe with Mamah in 1909. She was translating feminist books on free love from German and Swedish. The couple eventually settled in Wright's Taliesin compound in southern Wisconsin, but their relationship ended tragically in 1914. Julian Carlton, a deranged 30-year-old chef from Barbados, set fire to the house while Mamah was enjoying a visit with her young son and daughter. As everyone tried to escape the blaze, Carlton attacked them with a huge axe. Seven people were killed, including Mamah and both her children. Wright was in Chicago at the time supervising the completion of the Midway Garden, a large open-air entertainment facility in Hyde Park.

Sam Giancana (1908–1975)

"Momo" was a vicious syndicate godfather who ordered at least 100 gangland executions. Yet his neighbors insisted he was a "model citizen," a quiet man who kept to himself. In 1975, mobster Sam Giancana was executed in his basement with seven bullets fired at close range from a .22-caliber gun while he was cooking sausage and peppers. The case is one of Oak Park's most notorious unsolved murders. Momo Giancana had been an abused child on Taylor Street in the old West Side Italian enclave. During Prohibition, he joined a violent street gang. By the time he was 18, he had been arrested over 20 times. He worked his way up to a position of power in the Chicago Outfit. In the 1940s, he served an 18-month prison sentence for refusing to talk. Giancana was said to have strongly influenced the 1960 election of John F. Kennedy. At the time, both men were involved with Judith Exner, who was often stashed at the Oak Park Arms Hotel whenever she was "visiting." During the 1960s, Giancana's profile grew to international proportions. He was credited with devising the Latin American drug trade. Law enforcement officials also linked him to a plot to kill Cuban dictator Fidel Castro. But by the 1970s, Momo had fallen out of grace with Tony "The Tuna" Accardo, who lived in neighboring River Forest, and other syndicate bosses. Though no one has ever been charged with the killing, his murder is believed to have been a mob-ordered hit.

Antoninette Giancana

In 1984, Sam Giancana's daughter Antoinette (born in 1935) wrote a memoir titled *Mafia Princess*. It was subsequently made into a 1986 television movie, in which Susan Lucci portrays the mobster's daughter and Tony Curtis plays dad Momo. In 1987, at the age of 52, Antoinette posed for photographs in *Playboy*.

Joe Tinker (1880–1948)

Hall of Fame baseball player Joe Tinker was a Chicago Cubs shortstop who led his team to four National League pennants and two back-to-back World Series championships in 1907 and 1908. He is best known for the years he played with the Cubs. He is often remembered for the "Tinkers to Evers to Chance" double-play combination, with second baseman Johnny Evers and first baseman Frank Chance. After a 1905 fistfight with fellow Cub Evers, they refused to speak to one another again, though they played alongside each other for seven more years, turned numerous double plays, and won a couple World Series—all without uttering a single word between them.

Rheinhold Kulle

In 1980, the head custodian at Oak Park and River Forest High School, Rheinhold Kulle (born in 1921), seen in a 1966 yearbook photograph, made headlines. His mere presence plunged Oak Park into a stark moral dilemma when it was discovered that Kulle had been a member of the Nazi SS in World War II. During the years of the Holocaust, he served the Third Reich in its notorious "Death's Head" battalion. Beginning in 1942, he was a guard and a training leader at Gross-Rosen, a concentration camp in his native Silesia (now Poland), where he was overseer of slave laborer prisoners who worked in brutal conditions in granite quarries. He also participated in the selection and transport of "deportees" to the Mauthausen camp. After the war, Kulle misrepresented facts and lied on his immigrant visa application to come to America. When all this was revealed, Oak Park people were shocked and confused.

In a prolonged and emotional public debate, many members of the community demanded that he be immediately removed from the high school. Yet others defended Kulle's right to stay, insisting he was now a hardworking "model citizen." Kulle, however, never expressed regret or made any excuse for his past. Ultimately, he was deported back to Germany in 1987, but the statute of limitations had run out on his alleged war crimes.

"Three-fingered" Jack White (1900–1934)

He was a ruthless, convicted cop killer whose nickname "Three Fingers" came from his missing two digits on his right hand. Hoodlum Jack White, a gunman in the Al Capone organization, was so self-conscious of his deformity he wore white gloves with cotton stuffed into the empty fingers. Some said he lost those fingers in a botched safecracking explosion. White first served time at Joliet Penitentiary for robbery in 1919. Throughout Prohibition, he was regarded as one of Chicago's most vicious criminals. In 1924, he was convicted and again imprisoned for the roadhouse murder of a Forest Park officer. Upon his release, White married a "flapper showgirl" named Nancy Kelley. The couple lived in a third-floor north-front apartment at 920 Wesley Avenue. His wife "was just leaving" their flat to attend a matinee when two men (believed to be Klondike O'Donnell and Murray Humphreys) arrived to visit Jack. He was shot to death in the couple's bedroom. Police found him slumped over a dresser drawer, presumably trying to grab one of his pistols. Some theorize it was White, not mobster Al Capone, who led the hit squad in the 1929 St. Valentine's Massacre. Melvin Purvis, FBI agent, claimed White had been cooperating too closely with investigators in 1934, so mob enforcers silenced him. Gavin MacLeod portrayed him in *The Untouchables* television series. In the 1926 courtroom scene are, from left to right, Jack White with his right hand tucked into his pocket, Red Barker, defense lawyer Michael Ahern, and Al Capone. White is second from left in the image below. (Both, courtesy of Mario Gomes, Al Capone Museum.)

Jonas Stankus

In 1971, the old Lowell School at Lake Street and Forest Avenue was sold to developer Jonas Stankus (born in 1923) for $1.4 million. He immediately razed the structure, creating a three-acre block square gaping ravine that bore the name "Stankus Hole" for over a decade. That vast, centrally located eyesore, long an emblem of shame in Oak Park, became a symbol for economic downturn at a vulnerable point in the village's identity. Stankus, a Lithuanian architect, who had fled the Nazis 30 years earlier, planned to build twin 56-story towers on the site containing 1,172 apartments. His plan made a lot of Oak Parkers very uncomfortable, however. As soon as excavation began, there was intense opposition from citizen groups. So Stankus scaled back his project to a single 37-story high-rise. Though supporters felt that the structure might spur the already floundering pedestrian shopping mall adjacent on Lake Street, the controversy continued. After a variety of legal and economic complications, the Stankus Hole project crashed, so the village bought the land back for $1.5 million. Then for 13 years, it sat there, a massive ugly panorama in west central Oak Park. Finally, in 1984, another firm completed 100 Forest Place, a single 15-story mid-rise building with 234 apartments, surrounded by 30 townhouse rental units.

David Axelrod

During his Oak Park years, from 1980 into the 1990s, David Axelrod (born in 1955) was political editor at the *Chicago Tribune* and a political consultant. He is one of the most influential men of the late 20th and early 21st centuries. Axelrod was the top political advisor to Pres. Bill Clinton and campaign advisor and strategist to Barack Obama during his successful run for the presidency in 2008. He was appointed senior advisor to the president, playing a major role in framing the president's domestic agenda. He became senior strategist for Obama's reelection in 2012. Axelrod is a dedicated father whose daughter Lauren's severe epilepsy left her disabled; Axelrod and his wife, Susan, advocate for epilepsy organizations and cofounded CURE (Citizens United for Research in Epilepsy). Axelrod spends every Passover with Oak Park friends.

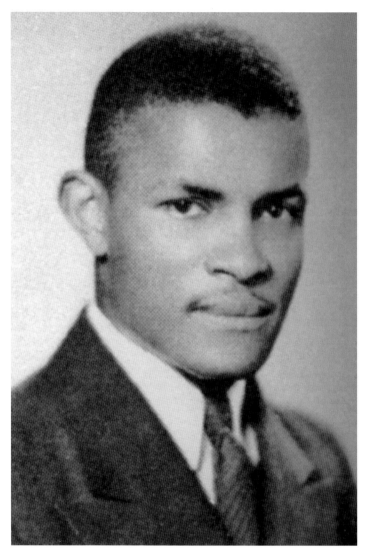

Lewis Pope (1920–1998)

There were few African American students at Oak Park High in the 1930s. One of them, a popular young man who played quarterback, Lewis Pope, was nicknamed "The Ebony Streak." The 1938 Oak Park football team, one of the top-rated high school squads in the nation, was invited down to Miami over the holiday break to play in the Orange Bowl. But Florida authorities were quick to qualify that, due to the Jim Crow segregation practices of the period, the team could not bring Lew Pope with them. He was left standing on Scoville Avenue, waving goodbye to his teammates, as their bus pulled out of the parking lot. Dr. Percy Julian, then living in Maywood, wrote a letter to the newspaper decrying the injustice of the school's choice of action. Other community members were vocal in their disappointment that the administration's decision was to send the team without Pope. On Christmas Day 1938, as the big game was about to be played, Pope received a standing ovation when he came on stage in the school auditorium packed with fans. Lew wore a headset so he could relay results from the "direct wire" hookup being broadcast from Miami. The game ended in a tie, 6-6. But fans lingered, showing their support for Pope. After college, he served in the Pacific during World War II. He settled in Springfield, Massachusetts, was the first African American in that region to open a nightclub, and became a successful businessman.

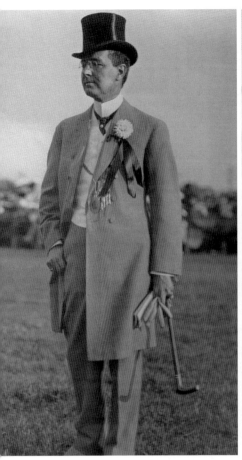

John Farson (1855–1910)

John Willington Farson was an investment banker with a national reputation in municipal bonds. He was a jolly, highly energized man who was widely known for his generosity and his zest for life. The colorful financial wizard and self-made millionaire started out as a lawyer but made his fortune with the new electric street railways. He was one of the key financiers who helped Chicago become a front-runner in commerce and industry in the post–Chicago Fire period. Convinced red was his lucky color, Farson always wore a red necktie, a red vest, and a top hat. (He owned 175 neckties, all red.) A fresh-air enthusiast, he slept, wearing red silk pajamas, on his open-air upstairs porch much of the year. He is seen at the Oak Park Horse Show in 1905. When the first automobiles were produced, they cost as much as brick homes and were called the "playthings of the rich"; Farson owned five of them. He was the president of both the Chicago Auto Club and the American Automobile Association. Though not Roman Catholic himself, he supported efforts to help establish St. Edmund Parish. He also assisted an African American congregation, Mount Carmel Colored Church, with building its house of worship. When roller-skating became a fad, he had smooth cement sidewalks added to his grounds and encouraged neighbor children to skate on his broad front veranda. He even took up the sport himself. He was widely acknowledged as the financial power behind William McKinley's victory over William Jennings Bryan in 1900. Farson's 1897 Prairie School mansion at Pleasant Street and Home Avenue, known as Pleasant Home, was his pride and joy. It is now a National Historic Landmark open for tours.

Michael Spilotro (1945–1986)
The 1995 Martin Scorsese movie *Casino* is a fictionalized version of the case of the Spilotro brothers. The character Dominick Santoro, played by actor Philip Suriano, is based on Michael Spilotro. His brother Anthony, "Tony the Ant," was a mob chieftain who was being investigated in connection with at least seven murders (and possibly 25). Tony was scheduled to go on trial the following week when he and Michael, also a reputed "outfit" member, both went missing. Tony had been an irritant to his mob superiors who did not like his high profile in Las Vegas. Since he was facing criminal trials in both Chicago and Vegas, the big syndicate bosses were concerned he might become an informant. Michael, the manager of Hoagie's restaurant at 6978 West North Avenue, may not have been an intended target but was at the wrong place at the wrong time. The brothers, summoned to a meeting, left Michael's home in his new 1986 dark gray Lincoln Continental on Father's Day weekend 1986. Oak Park police initially treated their disappearance as an average missing person's case. They checked all the brothers' usual hangouts. Then, an Indiana farmer discovered the bodies of Tony and Michael Spilotro in a shallow grave in his cornfield. The brothers had been stripped to their underwear and savagely beaten beyond recognition. (Courtesy of *Wednesday Journal*.)

Tony Lawless (1904–1976)

He was a tough, no-nonsense disciplinarian who demanded excellence. Within a couple years after arriving as a young couch at Fenwick, a Catholic boys' high school in Oak Park in 1929, Tony Lawless established his Fenwick Friars as a power in the Chicago Catholic League that dominated for decades. As a football coach, Lawless compiled a 127-23 record and won 14 divisional, 5 Chicago Catholic League, and 3 city championships. Lawless also achieved an outstanding record as a basketball coach. During his 48 legendary years at Fenwick, he also developed the strongest swimming program in the Chicago Catholic League and conducted an annual intramural boxing tournament. Lawless always carried a full schedule of physical education classes each semester. He was said to work virtually 365 days a year, and he never took a sick day. He died at 72 during his 48th school year at Fenwick. The award for the top athlete in the Chicago Catholic League is named for Lawless.

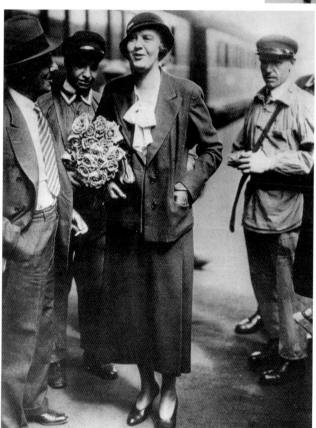

Dorothy Thompson (1893–1961)

She was called the "First Lady of American Journalism." Dorothy Thompson, a noted 1920s newspaper correspondent, was one of the first women news commentators on radio. In 1934, she was the first American journalist to be expelled from Nazi Germany. Her marriage to novelist Sinclair Lewis was portrayed in the 1979 Broadway play *Strangers*; Oak Park native Lois Nettleton played Thompson in that production.

Charles Gawne (1884–1972)

People often described Charles Gawne as "Cagney-esque" for his scrappy, don't-mess-with-me persona. The first of his 11 siblings to be born in the United States to immigrant parents from the Isle of Man, he converted to Catholicism when he married. Many assumed Gawne was Irish. In that era, there was strong prejudice toward Irish people. It was not uncommon to see "Irish need not apply" posted in shop windows. Gawne was the first Catholic to be elected to public office in Oak Park when he was voted onto the village board with a landslide in 1932. He frequently stood up to Willis McFeely, the village president, who was said to be an intolerant bully. McFeely once ordered

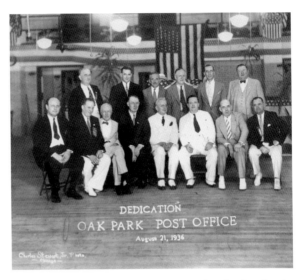

DEDICATION
OAK PARK POST OFFICE
August 21, 1936

the police to throw Gawne out of a board meeting, but the trustee stood his ground and refused to be moved. He spoke up for the working class and never left south Oak Park. Shown at the 1936 dedication of Oak Park's WPA-funded post office, he is wearing white pants and shoes near the far right of the first row. Gawne was the plumbing superintendent of landmarks like Chicago's Drake Hotel, the Morrison Hotel, Union Depot, Hines Hospital, Buckingham Fountain, and Comiskey Park. His successful plumbing business is still in the Gawne family. (Courtesy of Christine Vernon.)

Ellis Coleman

His early life was tarnished by trouble. Ellis Coleman's father, a drug dealer, went to prison. But his mother, Yolanda, and his wrestling coach refused to give up on him. "Ellis was the hardest-working kid I've ever coached," says Mike Powell of Oak Park and River Forest High. Ellis (born in 1992) achieved fame for his amazing signature "flying squirrel" takedown move. At 20, Coleman became the youngest member of the US Greco-Roman wrestling team and made it to the 2012 London Olympics. (Courtesy of *Wednesday Journal*.)

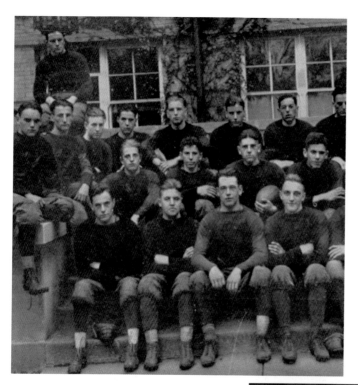

George Trafton (1896–1971)

The "fabled halfback," George Trafton, second from the left in the first row, came to notice playing football at Oak Park High. While he was at Notre Dame, famed coach Knute Rockne caught him playing semiprofessional football and had him expelled. Nicknamed "The Brute," defiantly wearing No. 13, Trafton became the first center playing for the team now known as the Chicago Bears from 1920 to 1932. Trafton, also the first center to snap the ball with one hand and was named top NFL center of the 1920s. In 1964, he was enshrined in the Professional Football Hall of Fame.

Phil Rock

Phil Rock (born in 1937) epitomized the ambitious politicians of the old-school Cook County Democratic Party. Before assuming elected office, Phil Rock served as an assistant Illinois attorney general and Cook County assistant state's attorney. As president of the 8th Congressional District, Rock's influence extended beyond Oak Park into the state. Elected to the Illinois Senate in 1979, he later served as senate president. Rock was elected chairman of the Democratic State Central Commission in 1982. He was a prolific legislator, sponsoring more than 400 pieces of legislation that became law.

Bob Zuppke (1879–1957)

He was too small to play football, so Bob Zuppke became one of the most inventive minds the sport has known. Born in Berlin, he came to the United States at the age of two. The pint-sized coach, known for his signature Napoleonic stance, introduced many practical ideas and "gadget" plays that became standard, such as the offensive huddle and the spiral pass. Zuppke taught history at Oak Park High and served as coach from 1910 to 1913. Oak Park was undefeated through the 1912 season. He then had a 29-year career at the University of Illinois, coaching the legendary "Red" Grange and George Halas. Illinois won four national titles under Zuppke. He was also a talented landscape artist, cartoonist, and humorist who raised hogs as a hobby.

Johnny Lattner

Born in 1932, he was called the "pride of Fenwick High School," and sports reporters considered him "one of the best-ever football players in the Chicago Catholic League." Johnny Lattner's credentials were impeccable. He made all-state his senior year and then All-American junior and senior years at Notre Dame. The Irish lost only four games during his three seasons on the team. Besides winning the Heisman Trophy in 1953, the 6-foot, 1-inch, 190-pounder was named a winner of the Maxwell Trophy for two consecutive years (1952 and 1953). No one had ever won two years in a row. Generations of young athletes emulated him. But Lattner never made it big in the pros. His career was cut short by injury. He played one season with the Pittsburgh Steelers and appeared in the Pro Bowl, but then, while in the armed forces, he injured his knee in a service game. It collapsed under him when he tried a comeback after his discharge. His original Heisman Trophy no longer exists. When his family's basement flooded in the 1950s, Johnny's mom used it to plug the leak. Later, when his popular Loop restaurant, Johnny Lattner's Steak House, burned down, it melted into a blob. In 1979, he was inducted into the National Football Foundation College Hall of Fame. Lattner can often be spotted enjoying his pancakes at George's Restaurant, located at 145 South Oak Park Avenue.

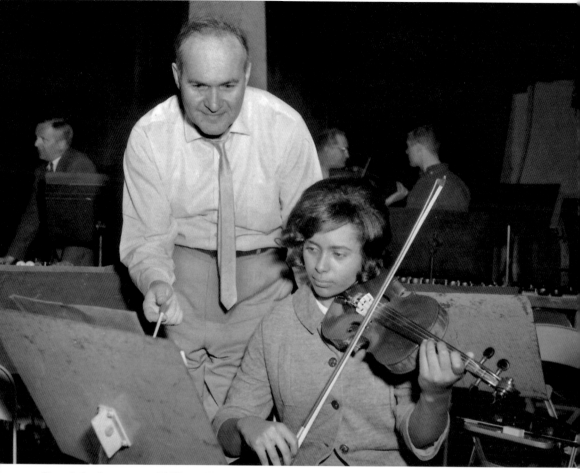

Carol Anderson and Milton Preves (1909–2000)

Good things often come out of bad. A 1963 racial incident served as a springboard for the open housing movement that led to Oak Park passing and, more importantly, enforcing its landmark fair housing ordinance five years later. Having played the violin since she was four years old, 23-year-old African American Carol Anderson of Chicago was hired by Oak Park Symphony conductor Milton Preves without his getting prior approval. Marie Dock Palmer (1894–1967), president of the symphony's board of directors and principal cellist with the orchestra, promptly dismissed Anderson, telling her in no uncertain terms that Oak Park just was not "ready for Negroes." Palmer informed Preves that if the black violinist were retained over her objections, the entire community would withdraw its support from the Oak Park Symphony. But Palmer could not have been more wrong. The outcry in support of Anderson and Preves was tremendous. The village board issued a statement deploring the incident. Outraged residents voiced their support for Preves and the 12 members of the symphony who had resigned in protest. After making a lot of stupid remarks to the Chicago press, Palmer was forced to apologize. The ugly 1963 incident was a wake-up call that led the village to start examining and changing its racial attitudes. All the intense media attention and citizen support resulted in the Community Relations Commission being established in Oak Park.

CHAPTER FOUR

Business as Usual

Since the earliest frontier days, a variety of Oak Park entrepreneurs launched successful business ventures—from blacksmiths and harness-makers to shoemakers and shopkeepers. Milliners and dressmakers made house calls. Early funeral directors were often furniture dealers who built caskets as a sideline, ultimately "undertaking" everything from renting chairs and printing memorial cards to embalming. Charles Drechsler started his undertaking parlor in 1880.

Though there were many busy general stores and dry goods emporiums in Oak Park, William Y. Gilmore (1864–1941) ushered in a new era when he opened his Gilmore's Department Store (1908) in the large E.E. Roberts Building, which is currently occupied by Winberie's Restaurant, at 151 North Oak Park Avenue. Gilmore's, which had a popular tearoom on its mezzanine, was run by three generations of the local department store family until it closed in 1976.

By the late 1920s, Oak Park was becoming a regional shopping hub, easily accessible by the elevated and streetcar lines. Numerous automobile dealerships located along Madison Street drew customers from across the region. Big chain stores, like Marshall Field's, Lytton's, Woolworth's, The Fair, and The Hub, opened branches on Lake Street. But during the 1960s, when shopping malls boomed in the outlying suburbs, business severely dipped in Oak Park. In the desperate 1970s, the two-block stretch of Lake Street now referred to as downtown, between Forest Street and Harlem Avenue, was blocked off as a pedestrian mall. The mall struggled for nearly two decades, but after most of the big stores pulled out or went under, the experiment had clearly failed; the street was reopened in 1989.

Landlocked Oak Park now has 12 distinct business districts with no big-box stores. There are, however, 80 restaurants. Until the 1970s, there were few eateries other than hotel dining rooms, ladies' tearooms, and Woolworth's and Walgreen's lunch counters because no alcohol could be sold. But once the liquor prohibition was removed, a variety of exciting restaurants opened. Every type of ethnic cuisine, from Venezuelan to Indian, is available in the village today.

Oak Park residents are fiercely loyal to their favorite businesses. When Tasty Dog, a popular hot dog stand, was displaced by a large-scale redevelopment project in 2001, fans and supporters launched an instant, intense protest. Elementary school classes wrote letters, radio deejays urged village officials to step in, and huge groups picketed to save their fast-food favorite. Ultimately, the village board caved and then built a new million-dollar Tasty Dog, at taxpayers' expense, across the street. The residents of Oak Park often thrive on controversy and enjoy rallying for a cause.

Flora Gill (1847–1934)

Flora Gill was born in Maine. When her father, a sea captain and lighthouse keeper, died suddenly, she became the family breadwinner. She struggled to earn a living by painting china before settling in Oak Park and becoming a milliner. After quickly learning the trade, she opened a hat-making shop on the southwest corner of Lake and Marion Streets in 1876. Gill ran a very thriving Oak Park business at a time when ladies never left home without wearing a hat. In the late 19th century, a woman working outside her home was rare, but millinery was one of few socially acceptable "ladies' professions." Gill and her assistants custom-designed hats and bonnets for individual Oak Park women. Her hat shop became a social center. Gill graciously served tea and cake, knowing that the more time lady customers spent on the premises, the more they might make a purchase. Note the high wooden sidewalks in this 1884 photograph of Gill (right) with one of her assistants.

Dennis Murphy

Oak Park in the early 1970s was still dry (no legal liquor) and offered few restaurants. There were some corner diners and ladies' tearooms. But then Dennis Murphy (born in 1941) opened Murphy's Off the Mall at 163 North Marion Street, located a block north of then closed-off Lake Street; the pedestrian shopping mall between Forest and Harlem Avenues lasted two decades. Murphy's quickly became known for great cheddar burgers. Next, Murphy opened a kitchenwares store on Lake Street called Kettlestrings, honoring the names of Oak Park's first white settlers. Taking advantage of the soon-to-be-loosened long-standing local prohibition on alcohol, Murphy planned Philander's, a classy, linen tablecloth, wine list, chef-with-a-name restaurant in what had been the ballroom of the Carleton Hotel. Murphy lined the oak paneled walls with scores of framed early-1900s Philander Barclay photographs from the Historical Society of Oak Park and River Forest. In the 1970s, Murphy served local booster Elsie Jacobsen the first legal drink poured in Oak Park in over a century. Next came Poor Phil's, also named for photographer Barclay, a casual alternative to the more upscale Philander's, located at Marion and Pleasant Streets in the hotel's former corner drugstore space. For over four decades, Oak Park has been known for its abundance of good restaurants. Murphy is the man who got that ball rolling.

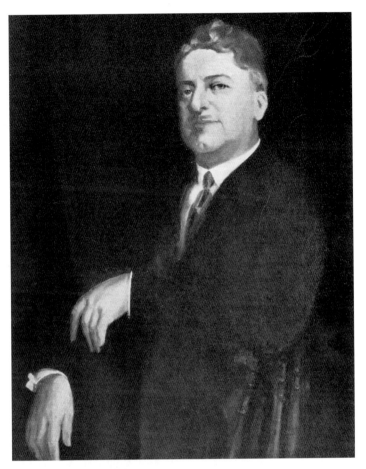

Herbert Mills (1879–1929)

When millionaire John Farson died suddenly in 1910, the top tycoon of
the coin-operated machine industry, Herbert Mills, purchased Farson's
Pleasant Home mansion. The grounds surrounding the Prairie School
residence were later named Mills Park in his honor. Mills was a self-
made man who started out as a preteen newsie, hawking newspapers
on street corners. Following an unsuccessful peanut concession at
the 1893 Columbian Exposition when he was in his early 20s, Mills
invented a "penny machine" that dispensed handfuls of Spanish peanuts.
He quickly cornered the penny-snack market as the "Peanut King."
Mechanically gifted, Mills developed a number of coin-operated vending
machines. The Mills Automatic Phonograph was an early nickel jukebox.
Mills's mechanical musical instruments could be found in almost every
ice cream parlor, dance hall, and saloon. In 1904, Mills perfected the
Mills Violino-Virtuoso, a coin-operated combination player piano and
self-playing violin. He served prison time following a censorship
clash in 1907 when some of his penny arcade kinescope machines
were found to be featuring suggestive hootchy-cootchy dancers.
Mills's biggest moneymaker by far was the slot machine. The Mills
Novelty Company employed over 1,000 people in Chicago manufacturing
coin-operated vending, musical, and gambling machines.

Jason Smith and Rachel Weaver

When the 2008 recession forced several bookstores in Downtown Oak Park to close their doors, the Book Table not only survived but also thrived and expanded. Husband and wife duo Jason Smith (born in 1972) and Rachel Weaver (born in 1973), who co-own the Book Table, first met in 1988 while both were employed in indie bookstores. They had worked in seven different bookstores between them. "Instead of babies," Rachel said, "we decided to have a bookstore." So they opened their business, directly across from the Lake Theater, in 2003. They love the fact that "Oak Park is a very urban suburb." Jason and Rachel work together, side by side, providing a successful new spin on the old mom-and-pop formula, which is friendly service in a homelike, informal setting. The couple has promoted the Book Table as "fiercely independent" since it opened. Many Oak Parkers refer to it as the "Cheers of bookstores," where folks know your name and are happy to see you. The store is well organized, jammed with an extraordinary selection of quality used books, publishers' overstock, and new releases at discount prices. Jason and Rachel host frequent author events and book signings. (Courtesy of *Wednesday Journal*.)

Ray Kroc (1902–1984)

He was a resident of Oak Park for over 40 years. Ray Kroc almost single-handedly created the fast-food industry and, for better or worse, changed the eating habits of the nation. Kroc always maintained that the secret of real success was not intelligence, education, or even talent; it was self-discipline. As a boy at Lincoln School, he played ball in the alley between the 1000 blocks of Wenonah and Home Avenues. He dropped out of Oak Park High at 15 when World War I began, falsifying his age to 18 to drive a Red Cross ambulance in France. During the Roaring Twenties, he was a jazz pianist with a variety of big bands. While serving as musical director on Chicago radio, he discovered a pair of blackface (actually "blackvoice") white comedians who became famous as Amos 'n' Andy. In 1955, Kroc was a salesman for a company that sold milk shake mixers to restaurants. He noted that brothers Maurice and Richard McDonald of San Bernardino, California, had bought enough mixers to make 40 shakes at one time. Kroc saw the huge profits their tiny restaurant was raking in by selling 15¢ burgers and 10¢ French fries made with assembly-line methods. Kroc struck a deal with them to franchise their operation. His quick-serve chain grew soon after. Kroc stressed cleanliness, fast but friendly service, low prices, and consistency. To discourage teens from hanging out, there were no pay phones or jukeboxes. Most of the earliest McDonald's restaurants did not even provide seating; they were strictly pay-and-pick-up window situations. When Ray Kroc died in 1984, there were 12,000 Golden Arches in 52 countries.

Al Mancini

Restaurateur Al Mancini, born in Italy in 1948 but raised in Chicago, is so excited about his business he often stops by tables to say hello and find out how diners are enjoying their meal. Mancini's Pizza and Pasta Café, 1111 Lake Street, is a cozy family-owned place in the heart of Downtown Oak Park. If one eats at Mancini's in the afternoon, he or she might even meet some of the grandchildren of proud Al and his wife, Mary. The kids drop by with their moms, the three Mancini daughters. Al's been in business since the mid-1970s, yet he constantly tries new dishes and expands his menu. Mancini's offers house-made Italian fare, like chicken vesuvio, margherita pizza, pumpkin ravioli in a black walnut cream sauce, meatball sandwiches, tiramisu, cannoli, and many flavors of gelato. Al's outside tables are popular for people watching on busy Lake Street. Mancini has hosted several special dining events at which portions of his profit have been turned over to Oak Park's Hephzibah House, a children's home. On November 11, 2011, he had a special promotion featuring a number of entrees for $11.11, with 20 percent of the tab going to Hephzibah. (Photographs by Allen Baldwin.)

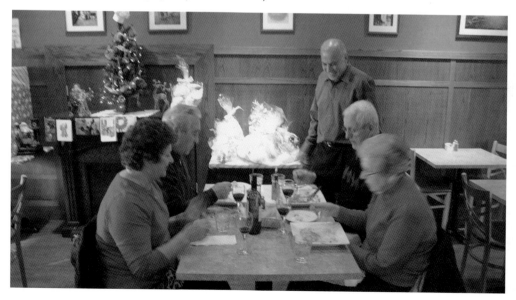

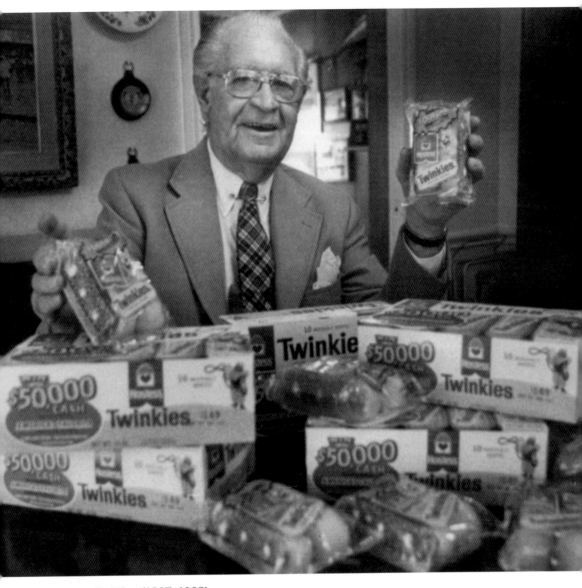

James DeWar (1897–1985)

The man who invented the Twinkie started out as a salesman delivering pound cakes by horse-and-buggy for the Continental Baking Company. James DeWar (pronounced DO-ER) was so enthusiastic and energetic, he quickly moved up to route supervisor and continued climbing in the company. In the depths of the Depression, DeWar knew they desperately needed a popular, low-priced item. So in 1931, he was inspired to mobilize hundreds of tiny cake pans that were lying around dormant after the brief strawberry shortcake season. DeWar got the idea of injecting each little sponge cake with a sugary cream-like filling, then wrapping them in pairs with clear cellophane (a new packaging) to ensure a longer shelf life. These 5¢ packages of snack cakes, which could be shared with a friend, were an immediate sensation. DeWar always took umbrage to Twinkies being called junk food. "I fed them to my four kids, and they feed them to my 15 grandchildren," the proud chain-smoker boasted at age 88. "I myself still eat two or three Twinkies every night with a glass of milk as a bedtime snack."

Donald Duncan (1899–1971)

He brought a marketing flair into his business ventures, turning existing products into household names. Though he became known as the "Yo-Yo King," Donald Duncan did not invent the yo-yo. The toy has roots in ancient Greece or possibly China. But he was the guy who made the yo-yo an American tradition. The shrewd businessman began mass-producing maple yo-yos in the early 1930s, and they became a national pastime during the Great Depression. "Duncan Yo-Yo

Professionals" toured the nation and Europe demonstrating yo-yo tricks, conducting contests, and popularizing the wooden toy. By 1946, the Duncan Toy Company was producing 3,600 yo-yos per hour. Duncan is also credited with introducing both the parking meter and a Good Humor ice cream product now known as the Eskimo Pie. Duncan's parking meters initially ran into public opposition. But the courts ruled that, while municipalities did not have the right to charge "rent" on parking places, they did have the power to eliminate motorist congestion by regulating allotted time and space available with "penny parking meters."

Richard Sears (1863–1914)

Left fatherless at age 16, future "Mail-order King" Richard Sears learned telegraphy to support his widowed mother and two sisters. While working as a railroad station agent, he discovered a shipment of unclaimed pocket watches at his depot. Sears purchased the watches to sell on consignment. Soon, repair orders also began pouring in, so he hired a young watch repairman named Alvah Roebuck to become his partner. The firm Sears, Roebuck and Co. grew rapidly. Within three years, Sears branched out with a catalog business. The partners billed their company the "Cheapest Supply House on Earth." Before long, they were selling everything from freckle cream to opera glasses and from sausage-stuffers to treadle-powered sewing machines. By 1894, the Sears catalog had grown to a hefty 322 pages and was mailed to 300,000 homes. Sears himself wrote all the copy. In 1908, he even launched a line of full-sized build-it-yourself prefab mail-order houses, such as the 1926 model below, that arrived by boxcar. Sears lived in a huge Victorian home across from St. Edmund Parish; it was razed in the early 1920s when the Oak Park Avenue business strip was developed.

Charlie Robinson

Born in 1945, he learned his 200-year-old barbeque recipe from his grandfather while growing up in the hardscrabble Mississippi Delta. It had been passed down in his family for 14 generations. He was one of eight children of a sharecropper living in poverty in a small shotgun house. As a youth, Charlie Robinson chopped and picked cotton on white-owned plantations, earning $3 for a 10-hour day. After college, while working as an Oak Park ice cream distributor, he entered, on a lark, Chicago columnist Mike Royko's first Annual Rib Fest. Charlie came in No. 1 out of 400 entries. A year later, "Mr. Barbeque of 1982" opened Robinson's Ribs at 942 Madison Street. Since then, the affable entrepreneur has launched a chain of rib restaurants with brisk carry-out business, plus a line of bottled products, including Robinson's signature barbeque sauce and hot sauce, which are on grocery store shelves in 37 countries. The community-minded, self-made man has often been the No. 1 vendor at the Taste of Chicago. In Oak Park alone, Robinson serves over 1,500 pounds of ribs per week, slow-cooked in a specially constructed hickory-wood smoker. While he will not divulge his family's treasured barbeque sauce recipe, Robinson does admit one of his preparation secrets is to rub "special spices" into the meat and refrigerate the ribs overnight before their smoking ritual begins. (Courtesy of *Wednesday Journal*.)

Val Camilletti

Born in 1939, Val Camilletti has been in the music business for over a half century. Camilletti, whose first record biz job was at Capitol Records in 1962, is known for her warm sense of humor and her encyclopedic knowledge of music. She does not just love it; Val lives and breathes music, "from oratorio to hip-hop," she explains. Val's Halla, her intimate record store (723 ½ South Boulevard), seen in a 1970s painting, was situated in a narrow space between two buildings, which was a diner during the Depression. Valhalla, in Norse mythology, was the great "Hall of the Gods" where slain heroes were enshrined by Odin. Val's Halla is a shrine where music lovers come to search the bins for everything from used vinyl to current releases. Due to recent redevelopment, Val had to move her store to 739 West Harrison Street in the arts district. The business has changed drastically since the 1960s, but Val has embraced the new business reality. "We're not dinosaurs," she clarifies. "We sell stuff online. We're on the Internet all day, working it." Val's dog Halla, a white German shepherd/lab mix, standing outside Val's Halla, was always on-the-scene greeting customers. (Above, courtesy of *Wednesday Journal*; right, courtesy of Val Camilletti.)

Frank Ross (1868–1947) and
Frank Skiff (1869–1933)

They were brothers-in-law, close lifelong buddies, and business partners who built houses next door to one another. Frank Ross and Frank "Fritz" Skiff were both quiet workaholics who sold tea and coffee door-to-door from a horse-drawn wagon. The pair pooled their funds and founded the Jewel Tea Company in 1899. During the early 20th century, they built their horse-and-buggy operation into a major grocery chain—Jewel Foods—that now has numerous branches throughout the region. At first, the two Franks did all the work themselves, delivering during the day and filling orders and packaging them at night. But as the partners expanded, they hired more help. As they opened new locations, they wanted each of their grocery stores to be "like a fine, precious jewel." Ross and Skiff's stores were the first chain stores to give away premiums. Customers could receive free merchandise, such as dishes or silverware, simply by purchasing groceries at their Jewel. Ross married Skiff's sister. The two men complemented each other and were very close. Their one-horse wagon business grew into one of the nation's largest supermarket chains. Today, there are 191 combination Jewel-Osco stores employing over 45,000 people. The Fred Blase Grocery, seen in the photographs, was one of many independent grocery stores thriving in Oak Park neighborhoods in the early 20th century when Ross and Skiff launched their chain.

Gus Cutsuvitis

In the late 19th and early 20th centuries, business enterprises were frequently determined by ethnicity. Oak Park had several Chinese laundries. Plumbers and roofers were often Irish; icemen were usually Scandinavian. Gus Cutsuvitis, a Greek immigrant, was typical of many enterprising young, single Greek immigrant produce merchants who came to the United States to seek their fortunes, hoping to return home as soon as possible. Eventually, Gus married and brought other members of his family to Oak Park. Greeks in that period tended to open fruit and vegetable markets, confectionery shops, and restaurants. The Cutsuvitis fruit stand, seen in this Philander Barclay photograph from around 1902, folded into a compact box when not in use.

Robert Nicholas (1882–1977)

During the 1920s, Robert Nicholas was the first merchant in Oak Park to sell radios and electric refrigerators in his hardware store, located at 121–125 North Marion Street. Recognizing the village's potential as a regional shopping center, Nicholas vigorously sought to lure large Chicago retail chains to open Oak Park branch stores. Now called the Shaker Building, his 1929 three-level hardware store employed over 100 people. Soon, other popular Loop stores opened in Oak Park. During the Great Depression, Oak Park's downtown business district was firmly established as one of the region's finest suburban shopping centers, easily accessible by the elevated, streetcars, and buses. He ran his own real estate business on the corner of Marion and Westgate Streets, intimately knowing every house and building in the community. In his 90s, Nicholas was still going to his office six days a week.

Willis and Shirley Johnson

In 1935, the home of 19th-century Oak Park realtor, temperance advocate, and politician Henry Austin was moved farther back off Lake Street so that the modern Art Deco–style movie house, the Lake Theatre, could be constructed on what had once been the Austins' front yard. The Lake immediately began drawing crowds of filmgoers. But by 1981, when Willis (born in 1937) and Shirley (born in 1936) Johnson first leased the theater, the once glamorous showplace was seriously showing its age. Much of its neon marquee was burned out, there was a faulty furnace as well as major boiler problems, plus the roof leaked every time it rained. There were also challenging summers without air-conditioning. And since there was no movie theater from the Loop to Oak Park, crowds of rowdy teens, lured by discount admission prices, often drove away adult customers. Lake Street was closed to traffic in the 1980s, but the floundering pedestrian mall, a flopped experiment, often looked like a ghost town except for the lines buying movie tickets. One by one, the chain stores bit the dust—Ward's, Woolworth's, Wieboldt's, Marshall Field's, Lytton's, and Kroch's & Brentano's. But Willis and Shirley persisted with their vision. They purchased the Lake Theatre in 1984, began a massive renovation and upgrading project, and even expanded into an additional adjacent storefront space. The Johnsons kept focused on lovingly preserving the 1930s decor. The resulting multiscreen theater was a tremendous shot in the arm for the redevelopment efforts of Downtown Oak Park. Willis and Shirley took a risk, but it paid off. These two theater preservationists continue to purchase old movie houses and restore them. Their Classic Cinema chain is now comprised of 13 theaters with 100 screens. (Left, courtesy of *Wednesday Journal*.)

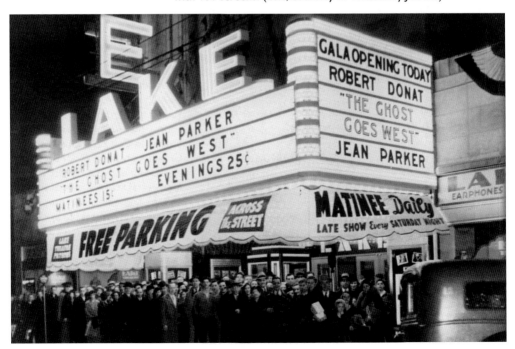

Takara Beathea-Gudell

Born in 1958 to West Indian parents, self-taught Takara Beathea began designing as a teenager. The lifelong artisan and fashion trendsetter was first drawn into fashion when she recognized the need for clothing that flattered mature, curvier women. Her designs showcase her love of elegant, free-flowing fabrics. Takara is often inspired by origami, employing daring shapes and lines to make bold statements. In the 1990s, she was the first African American woman featured on the cover of *Crain's Chicago Business*. The independent shop owner was chosen Oak Park's Merchant of the Year in 2006. She enjoys a wide following of customers from across the Chicago area. Takara designs clothing, jewelry, handbags, and one-of-a-kind accessories. She is president and CEO of Takara Designs, a fashion business enterprise that now includes three specialty women's boutiques in Downtown Oak Park. (Courtesy of Takara Designs.)

Ten Thousand Villages

Many friendly, dedicated Oak Park people—too many to list by name—work as volunteer clerks and greeters in the nonprofit store called Ten Thousand Villages, located at 121 North Marion Street. It is part of the oldest and largest fair trade organization in the United States. Partnering with thousands of talented artisans, the store sells handcrafted personal accessories, home decor, and gift items from low-wage, developing countries. The authentic worldwide imports—ranging from textiles, toys, musical instruments, and jewelry to coffee, tea, and even chocolate—come from Africa, India, Indonesia, and South America. By selling such a colorful array of handicrafts, Ten Thousand Villages creates opportunities for native artisans who would otherwise be unemployed or underemployed to earn a real income in a fair-trade relationship.

Dwight Follett (1903–1993)

At the University of Illinois in the 1920s, Dwight Follett played end on the famous team that starred Red Grange. His University of Illinois coach was former Oak Parker Bob Zuppke. After college, when Follett assumed his place with his three brothers in the bookselling business started by his father, he established Follett Publishing, which became known for its high-quality educational materials. He essentially created the modern textbook, developing format, teaching strategies, teachers' manuals, and other key features now considered standard. Though over draft age during World War II, Follett volunteered to serve in the Navy and was wounded in a Japanese air raid at Guadalcanal. In the postwar period, he pioneered the subject of elementary social studies, winning it a permanent place in the school curriculum. He was also the founder and president of the Village Manager Association (VMA), a nonpartisan political party that has dominated Oak Park elections from 1953 forward.

Iris Yipp and Rose Joseph

The ladies who own the Magic Tree Bookstore, at 141 North Oak Park Avenue, opened it in 1984 when their own children were little. In the three decades since, Iris Yipp (born in 1948) and Rose Joseph (born in 1943), two friends who shared a mutual love of books and kids, have seen their cozy, independent store blossom and grow into a much-loved destination. They stock only the highest-quality children's literature. While some chain bookstores rarely have knowledgeable clerks on hand, at the Magic Tree, staff is required to read the books stocked on their shelves. The store is an exciting and welcoming environment. Iris (far left) and Rose (second from left) schedule weekly story times and frequent special events. Also pictured are Rob Scotton, author of the Splat the Cat books, and Bethany Fort, storyteller. (Courtesy of *Wednesday Journal*.)

Buzz Café

The casual, community-oriented Buzz Café was opened by Laura (seen in the photograph with her son George) and Andrew Maychruk in 1998 just a half-block from the Blue Line elevated stop. The Buzz Café is located in the heart of Oak Park Arts District, a neighborhood of boutiques and galleries. The walls are covered with local artists' work, making the place feels like a loft living room. The Buzz, which specializes in homemade, organic, locally grown, vegan, and vegetarian foods, serves a diverse menu for breakfast, lunch, or dinner. The popular Oak Park business offers live entertainment, from poetry readings to bluegrass music, on Friday and Saturday nights.

CHAPTER FIVE

Showbiz

From the earliest years of the 20th century, Oak Parkers have been fascinated by show business. Each week, new theatrical productions were mounted at the Warrington Opera House at 104 South Marion Street. Vaudeville bills featuring jugglers, acrobats, magicians, comedians, song-pluggers, and animal acts were booked next door at the Oak Park Theater. When wired for sound in 1929, the Oak Park Theater was renamed the Lamar. Its new name was a composite of Lake and Marion Streets, so customers would be reminded of their streetcar stop. Oak Park went "movie crazy" in the 1910s and 1920s; however, due to the local blue laws, all theaters were closed on Sundays. For a time, there were five movie houses in Oak Park.

A number of Essanay silent movies, long presumed lost, were filmed in the village, around 1913–1914. A melodrama about labor unrest starring Wallace Beery was filmed along the iron gates of Pleasant Home at 217 South Home Avenue. Movies, such as parts of Robert Altman's *A Wedding* (1978), and a variety of television episodes and commercials have often been shot in Oak Park.

In May 1948, before Robert Kubicek actually owned a television set, he began to publish *Television Forecast*, the nation's first television magazine that evolved into *TV Guide*.

The number of Oak Parkers in the performing arts is still astonishing. There are technical, behind-the-scenes people as well as actors, performers, and directors. Kevin Sorenson is a renowned stuntman. Steve James (born in 1955) has produced the critically acclaimed documentaries *Hoop Dreams* (1994) and *The Interrupters* (2011). Amy Morton is a Steppenwolf Theatre Company actor.

Staats Cotsworth (1908–1979) was an accomplished radio and television actor who appeared on hit shows like *Bonanza*, *Dr. Kildare*, and *The Edge of Night*.

Anna Chlumsky (born in 1980) played Vada Sultenfuss in *My Girl* (1991) and had a starring role in the HBO series *Veep*. Mason Gamble (born in 1986) played the title role in *Dennis the Menace* (1993) at age seven and later appeared in *Rushmore* (1999) and *Arlington Road* (1999).

Peter Sagal (born in 1965), a playwright, screenwriter, and actor, is the well-known host of National Public Radio Show's game show *Wait, Wait . . . Don't Tell Me!*

A vibrant live theater scene flourishes in Oak Park. One especially active troupe, Open Door Theater, renovated an abandoned storefront at 902 South Ridgeland Avenue, located right at the Blue Line elevated stop. It offers strong dramatic productions as well as local musical groups, stand-up comedians, and staged readings of new works.

Tom Lennon

Born in 1970, he is an actor, writer, comedian, and film producer who writes for and has appeared in scores of popular television shows, from *Friends* to *How I Met Your Mother*. He also pops up in a lot of films playing roles such as a doctor in both *Memento* (2000) and *The Dark Knight Rises* (2012). Tom Lennon's long list of successful acting, writing, directing, and producing credits include *A Night at the Museum* (2009), *Herbie Fully Loaded* (2005) and *17 Again* (2009). He is the best-known cast member of the MTV series *The State*. Tom began his acting career early, performing with Oak Park's Village Players in *A Midsummer Night's Dream* when he was a high school sophomore. A 1988 yearbook photograph shows him (left) rehearsing for a student production of *The Foreigner* with classmate Claus Jensen. Lennon is seen playing gay Lt. Jim Dangle on Comedy Central's *Reno 911!* He was codirector, cowriter, and actor in the Sundance Film Festival selection *Hell Baby* (2013). Tom's father is a second cousin of Beatle John Lennon.

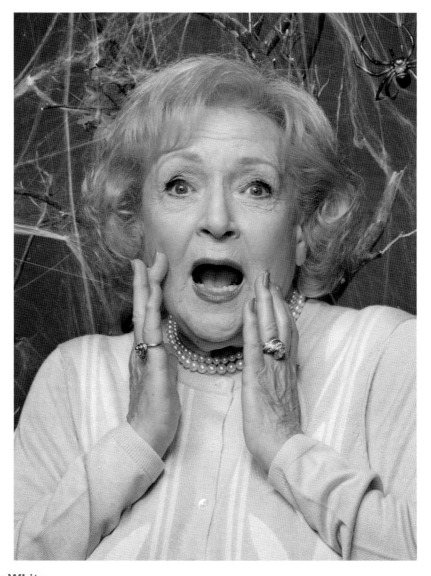

Betty White

The only child of Horace and Tess White was born in 1922 in Oak Park and always proudly identifies herself as an Oak Park native, but the little family moved to Los Angeles when Betty White was still a child. Though the actress, comedienne, and television personality had initially hoped to become a "serious writer," she began working in the 1940s on radio programs like *Blondie*, *Gangbusters*, and *The Great Gildersleeve*. In the early days of television, Betty became a popular host before she began portraying the zany title character on early sitcom *Life with Elizabeth*, an *I Love Lucy* competitor in 1952. White's career has spanned over seven decades. She has won seven Emmy Awards. She was a regular panelist on game shows like *Password*, *I've Got a Secret*, and *To Tell the Truth*. Betty had a long stint as hostess commentator of the Rose Bowl parade. Her comic roles on popular television sitcoms include devious Sue Ann Nivens on *The Mary Tyler Moore Show* in the 1970s, ditzy Rose Nylund on *The Golden Girls* in the 1980s and 1990s, and, beginning in 2010, Elka Ostrovsky on *Hot in Cleveland*. In 2010, Betty White became the oldest person to guest host *Saturday Night Live*. In 2013, White launched a new television show, *Off Their Rockers*.

Bob Newhart

Known for his stammering, deadpan delivery, stand-up comedian and actor Bob Newhart (born in 1929) did not start out in show business. After attending St. Ignatius College Prep (a Jesuit high school for boys) in Chicago, he completed his business degree from Loyola University and then served in the Army. His first LP record album of comedic monologues, *The Button-Down Mind of Bob Newhart* (1960), won the Album of the Year Grammy Award. But perhaps Bob is best known for his 1972–1978 sitcom, *The Bob Newhart Show*, in which he portrayed a Chicago psychiatrist and Suzanne Pleshette played his wife.

Cecily Strong

She (born in 1984) has performed regularly at Second City, the Improv Olympic, and a variety of Chicago area comedy venues. Cecily Strong has also appeared with the all-female improv group Virgin Daiquiri. She has appeared in shows at the Goodman Theater, the Bailiwick Theater, and the Mercury Theater. Strong joined the cast of *Saturday Night Live* in its 38th season (2012–2013) as a featured player.

Mary Elizabeth Mastrantonio
She (born in 1958) has referred to herself as "the shyest member of my high school theater department."
Yet after she left Oak Park, Mary Elizabeth Mastrantonio, the daughter of Italian immigrants, was directed
by giants of film like Martin Scorsese (*The Color of Money*), Brian DePalma (*Scarface*), Roger Donaldson
(*White Sands*), John Cameron (*The Abyss*), and John Sayles (*Limbo*). She has acted opposite the likes of
Al Pacino, Paul Newman, Tom Cruise, Ed Harris, and the "Three Kevins"—Costner, Kline, and Spacey.
She was nominated as Best Supporting Actress for playing Carmen, Tom Cruise's tough girlfriend, in
The Color of Money (1986). Her work in film enabled her to do live theater, her first love, and to do her
cabaret-style singing. She won raves recreating the role of Dulcinea in the Broadway revival of *Man of La
Mancha* (2002). She is seen here in the 1989 science-fiction film *The Abyss*. Mastrantonio plays the fishing
boat captain in *The Perfect Storm* (2000), and has a recurring role on the television drama *Without a Trace*.
She now lives with her husband, director Pat O'Connor, and her children in London.

Johnny Galecki

The future sitcom star was born in Bree, Belgium, in 1975 while his father was stationed there in the Air Force. Johnny Galecki's family moved to Oak Park when his dad became a teacher rehabilitating blind veterans at Hines Veterans Hospital; sadly, he was killed in an accident when Johnny was 16. The acting bug bit Johnny early. He played early roles with Oak Park theater groups, appearing first as one of the children in the Village Players production of *Fiddler on the Roof*. At age 11, he received a Joseph Jefferson citation nomination for portraying John Henry in *The Member of the Wedding*. Galecki made his feature film debut in 1988 as River Phoenix's little brother in *A Night in the Life of Jimmy Reardon*. His first big break came in 1989 when he played Chevy Chase's son, Rusty Griswold, in *National Lampoon's Christmas Vacation*. Johnny lived alone, without adult supervision, in a studio apartment in Los Angeles while he was in his teens. He has appeared in many films, but he is most often remembered for his roles as Darlene Conner's boyfriend David Healy in seasons 4–9 (1992–1997) of the long-running ABC sitcom *Roseanne*, and, since 2007, as geeky but lovable scientist Leonard Hofstadter on CBS's *The Big Bang Theory*.

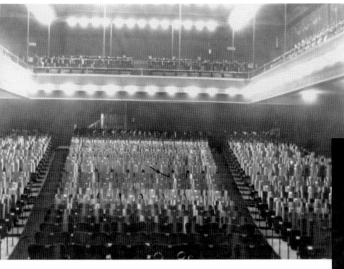

Grace Hayward (1868–1959)

Though actress, comedienne, and playwright Grace Hayward's accomplishments were not particularly innovative, she was a huge star in Oak Park who was long remembered for her great warmth, generosity, and her uninhibited, fun-loving nature. In the era before movie theaters and radio broadcasts, her popular Grace Hayward Stock Company launched a new production every single week at Oak Park's Warrington Opera House, located at 104 South Marion Street. For six seasons, from 1909 to 1915, her troupe performed six evenings and three matinees per week. Hayward usually cast herself as leading lady. Because of Oak Park's blue laws, theaters could not be open on Sundays, so that single "dark day" allowed an all-day rehearsal between productions. The company routinely played to sold-out houses. Hayward was an outspoken advocate of the women's suffrage movement and often appeared at rallies supporting the cause. Fiercely independent at a time when an unescorted woman could not even dine alone in a restaurant, Hayward hired and fired; battled agents; paid salaries; leased theaters; arranged tours, bookings, and lodging for her company; and directed every show each season. George Gatts, the dashing young impresario who managed Hayward's bookings, married her in 1910. Gatts was 26; Hayward was 42. But suddenly, with the overnight popularity of silent films in Oak Park (three movie houses opened in 1913), live stock shows faced stiff competition. As villagers went "movie crazy," attendance at the Warrington dropped drastically. In 1915, Grace and George relocated to California, where the actress wrote movie treatments and screenplays. In 1990, Doug Deuchler (the author) and composer Jon Steinhagen collaborated on *Kick Up Your Heels*, a musical comedy about Hayward that was directed by Michael Termine at Village Players Theater.

Dan Castellaneta

The versatile, improvisational voice actor Dan Castellaneta (born in 1958) did cameos on scores of television shows, from *Murphy Brown* to *Everybody Loves Raymond*. But three-time Emmy Award winner Castellaneta is mostly known for creating the voice of Homer Simpson, the loutish but lovable television dad. His performance career started early. Dan's father bought him a dummy and pushed him into doing a ventriloquist act for a Boy Scout banquet. Through his teens, Dan entertained his family and friends with showbiz impressions. But at Oak Park and River Forest High School in the 1970s, he was repeatedly told that entertainment was "not realistic or practical" as a career path and that he should try "something more sensible." So Castellaneta earned a degree in art education from Northern Illinois University in 1979. But during a run with the Second City improv troupe, his pal George Wendt recommended Dan to Tracey Ullman for her Fox variety show that featured a cartoon skit called *The Simpsons*. That recurring spot spun off into its own popular series in 1989.

Julie Haydon (1910–1994)

Her real name was Donnella Donaldson. Her father was the editor and publisher of the local newspaper, the *Oak Leaves*, and her mother was a musician. The young actress, who became Julie Haydon and began auditioning in her teens, appeared both on the New York stage and in a string of Hollywood films, such as in RKO's *The Conquerors* (1932), directed by William Wellman. A Hollywood legend persists that it was actually Haydon who provided the piercing screams for Fay Wray in RKO's *King Kong* (1933). In the initial MGM movie in the Andy Hardy series, *A Family Affair* (1937), she plays Mickey Rooney's relative. Julie debuted on Broadway in *Bright Star* by Philip Barry, who wrote *Holiday* and *The Philadelphia Story*. In 1939, she played prostitute Kitty Duval in William Saroyan's Pulitzer Prize–winning drama *The Time of Your Life*. In the 1944 Chicago premiere of Tennessee Williams's *The Glass Menagerie*, Haydon was the original Laura Wingfield, the lame, lonely girl who lives for her collection of animal figurines. In the 1980s, she played Alma Wingfield, Laura's mother, in several revivals of the classic drama. Haydon was married to much older drama critic George Jean Nathan (1882–1958). She often played in live dramas broadcast on early television, such as the Armstrong Circle Theater and the Kraft Television Theater.

Kathy Griffin

The youngest of five children, comedienne, television personality, writer, and LGBT activist Kathy Griffin (born in 1960) was already making her neighbors laugh when she was a young child. At Oak Park and River Forest High, she appeared in school musicals, playing Rosemary in *How to Succeed in Business* and Hodel in *Fiddler on the Roof*. Kathy is seen in several high school yearbook photographs. While she attended Triton College for one semester, she made her first television appearance as an extra on a White Sox commercial. Kathy moved to Los Angeles, where she studied drama and became a member of an improv comedy troupe. In the 1990s, she did stand-up comedy and played one of Jerry's ex-girlfriends on *Seinfeld*. The red-haired actress became known for her fast-talking rants, often making fun of celebrities. She has won two Emmy Awards for her reality show *Kathy Griffin: My Life on the D-List* (2005–2010). Griffin has had four best-selling comedy albums.

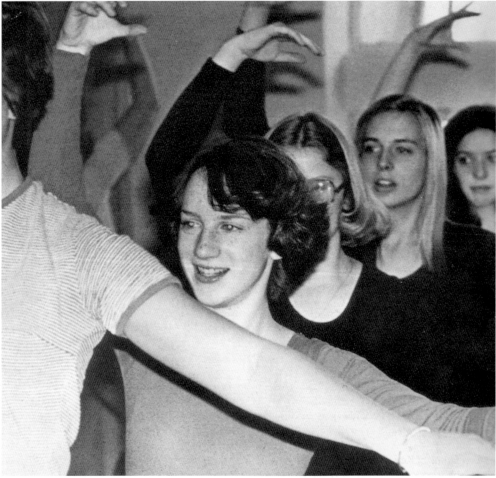

John Mahoney

He is such a dedicated walker that folks scarcely turn their heads any more when they spot actor John Mahoney (born in 1940) strolling through Downtown Oak Park. The most visible of celebrities, the Tony-winning actor (*House of Blue Leaves*) attends theater, buys mystery novels, shops in Whole Foods, and dines in local restaurants. He has always been enthusiastic about living in Oak Park. Born the son of a baker in England during the Nazi blitz, Mahoney came to live in Illinois with his war-bride sister after World War II. He tried a lot of jobs, from hospital orderly to English professor at Western Illinois University, and so, he did not begin acting until he was 40. He has performed extensively on stage in Chicago and on Broadway, as well as appearing in 30 movies, such as *Eight Men Out*, *Moonstruck*, *Say Anything*, *Tin Men*, *Suspect*, and *The Russia House*. He frequently plays key roles in productions at Steppenwolf Theatre. But he is most often remembered for his long-running role as Marty Crane, the ex-cop father of Kelsey Grammer, on the NBC sitcom *Frasier* (1993–2004). He is seen at Poor Phil's in his neighborhood. (Courtesy of *Wednesday Journal*.)

Tony Sarabia

Tony Sarabia (born in 1963) is a popular and award-winning radio journalist at Chicago Public Radio. In addition to his in-depth morning interviews, Sarabia hosts a Friday night show called *Radio M*, which explores music from around the world.

Ludacris

Christopher Bridges, better known as Ludacris, wrote his first rap song at age nine. Arguably the most commercially successful rapper, he has also had a distinctive career as a movie actor in such films as *Crash* (2004) and *Hustle and Flow* (2005), winning a Screen Actors Guild, Critic's Choice, and MTV awards, plus three Grammy awards. Ludacris has sold 17 million albums in the United States and 24 million worldwide. He is the coauthor of *Disturbing the Peace*, an imprint distributed by Def Jam Recordings.

John Sturges (1910–1992)

His name may no longer be familiar, but the films of John Sturges remain popular among action movie-lovers. He was a reliable Hollywood craftsman who became a top director in the 1950s and 1960s with a series of intense, morally charged pictures, such as *Bad Day at Black Rock* (1955) and *The Magnificent Seven* (1960). Sturges started his career as a film editor, directing Army training films and newsreels during World War II, and then directing a series of cheap but distinctive B movies in the late 1940s. His films had special appeal for male audiences seeking adventure and escapism. Neither *The Great Escape* (1963) nor *Ice Station Zebra* (1968) features any female cast members. Sturges directed the movie version of fellow Oak Parker Ernest Hemingway's novella *The Old Man and the Sea* (1958). Seen on the set of *Gunfight at the O.K. Corral* (1957) are Burt Lancaster (left), Tom Stern (center), and Sturges.

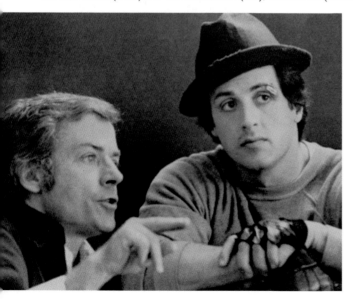

John G. Avildsen

Born in 1935, he started out his cinematic career as an assistant director working with Otto Preminger and Arthur Penn. John G. Avildsen's first big splash on his own was the low-budget feature *Joe* (1970), starring Peter Boyle as a blue-collar loudmouth confronted by the hippie counter culture. In films like *Save the Tiger* (1973), *The Karate Kid* (1984), and *Lean on Me* (1989), Avildsen showed his unique skill for inspiring audiences through the triumphs of underdog characters. He is seen directing Sylvester Stallone in the title role of *Rocky* (1976), which won Oscars for Best Director and Best Picture.

Judy Tenuta
Born in 1956, she was one of nine children. Entertainer, comedienne, actress, and wisecracking accordionist Judy Tenuta often features her offbeat, exaggerated persona "the Love Goddess" in her acts. Sometimes she calls herself "Princess of Panty Shields" or "Aphrodite of the Accordion." Tenuta's comedy albums and cable television stand-up specials on HBO, Showtime, and Lifetime won her a huge fan base. She has always been a strong advocate for gays, children, and women's issues.

Mercita Demonk

The Oak Park actress, singer, and dancer has been performing since the age of three. Mercita DeMuynck (born in 1932), who professionally goes by the "stage spelling" DeMonk, worked on radio as a teenager and was a bandstand singer. While raising her family with musician husband, Frank DeMuynck, Mercita became one of the movers and shakers of Oak Park's Village Players Theater in the early 1960s. She later was a founding member of the Oak Park Free Readers Ensemble. Along with her work on television and radio commercials and numerous stage roles, she directs and acts in live radio shows at the Chicago Cultural Center. She tours Illinois as Jane Addams in her one-woman show, *The Angel of Halsted Street*. In a "Tale of the Tombstones," one of the annual cemetery walks produced by the Historical Society of Oak Park and River Forest at Forest Home Cemetery, Mercita is seen portraying German-born Sophia Kohn (1828–1903), the last saloonkeeper in Oak Park, who was forced to close her saloon when the so-called dry century began in the 1870s. Mercita is doing a waltz with Wil Nifong in the 2013 Open Door Theater production of *Six Dance Lessons in Six Weeks*. (Above left, courtesy of Historical Society of Oak Park & River Forest; below left, courtesy of Open Door Theater.)

George Schaefer (1920–1997)

He never lost his love of theater and continued directing until he died. George Schaefer formed a group called Pastime Players after his 1938 high school graduation and then studied stage directing at the Yale School of Drama. He began directing while in the Army during World War II. Schaefer staged over 50 productions for the troops. After the war, he directed productions on Broadway and for television. In 1953, he won a Tony Award for his production of *The Teahouse of the August Moon.* He created NBC's *Hallmark Hall of Fame* and directed television adaptations of Broadway shows. Schaefer's television work won five Emmy Awards out of 21 nominations. He also won four Directors Guild Awards out of 17 nominations. Some of his most popular television productions are *Abe Lincoln in Illinois* (1964), starring Jason Robards; *The Last of Mrs. Lincoln* (1972), with Julie Harris; and *A Piano for Mrs. Cimino* (1982), with Bette Davis.

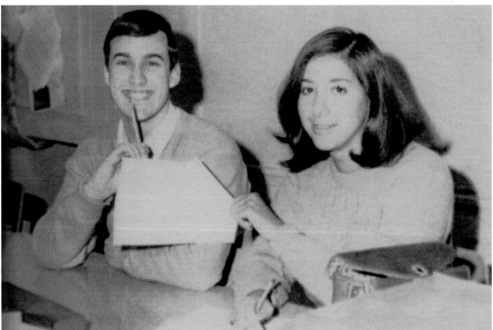

Bill Zwecker

The award-winning journalist (born in 1949) was a history major in college. Bill Zwecker, seen here in high school when he was feature editor of the *Trapeze,* is seated with fellow staff member Jackie Cooke. He worked in retail management and politics before he began his powerhouse career in entertainment journalism. Zwecker has long been a columnist for the *Chicago Sun-Times* and a television critic. Twice awarded the prestigious Peter Lisigor Award, Chicago journalism's highest accolade, Zwecker is known for his involvement in civic and charitable causes. His mother was a pathbreaking woman journalist.

Lois Nettleton (1927–2008)

She often said she was a lonely child of poor parents, who used fantasy as an escape, and performed backyard shows for her neighbors. Lois Nettleton did well in beauty pageant competitions after high school, winning the title of Miss Chicago 1948. After being a semifinalist in the Miss America Pageant, she studied acting at Chicago's Goodman Theatre and the Actors Studio in New York City. She understudied Barbara Bel Geddes in the role of Maggie the Cat in the original Broadway production of Tennessee Williams's *Cat on a Hot Tin Roof*. After appearing in the off-Broadway production of *Look, Charlie*, Nettleton married the playwright and humorist Jean Shepherd. She appeared in scores of sitcoms and soap operas, from *The Golden Girls* to *Murder, She Wrote*. She is seen with James Coburn in *The Honkers* (1972).

Charles Dawson Butler (1916–1988)

As a teen in the 1930s, he was a cartoonist for the *Trapeze*, the Oak Park High School newspaper. Charles Dawson Butler did not stay with drawing but became an impressionist, imitating James Cagney and other movie stars of the day as a way of overcoming his shyness. This led to a long career as a voice actor. "Daws," as he was usually called, provided voices for many Hanna-Barbera cartoon characters, such as Yogi Bear, Huckleberry Hound, Quick Draw McGraw, Wally Gator, Snagglepuss, Baba Looey, Augie Doggie, Elroy Jetson, Snooper, and Blabber. He also did many commercials, providing the voices for Cap'n Crunch (Quaker Oats) and Snap, Crackle, and Pop (Kellogg's Rice Krispies).

Warren Trezevant

As a character animator and creative lead at Pixar Studios, Warren Trezevant (born in 1969) has worked on many feature films, including *A Bug's Life*, *Toy Story 3*, *Finding Nemo*, *The Incredibles*, *Ratatouille*, *Cars*, and *Cars 2*. Warren also created the Toy Story Zoetrope, an updated version of an "illusion of movement" device that predates motion pictures, which was featured at a 2005 exhibit called *Pixar: 20 Years of Animation*, which toured museums around the world. (Courtesy of *Wednesday Journal*.)

Rich "Svengoolie" Koz

Born in 1952, he is a popular Chicago horror movie host and a television icon known to generations of fans as wisecracking "Son of Svengoolie." Actor and broadcaster Rich Koz also writes and hosts *The Three Stooge-A-Palooza* program on WCIU-TV. He began in Chicago radio right out of college. Though Jerry G. Bishop created the original Svengoolie character, Koz took over the role of the Saturday monster movie host. He has a thick Transylvanian accent (said to be a blend of Bela Lugosi and Lawrence Welk), a tuxedo, a lot of bad jokes and song parodies, and an assortment of flying rubber chickens. To become "Sven," he puts on his own makeup, which takes 30 minutes. Koz has won numerous regional Emmy Awards. (Courtesy of Rich Koz.)

CHAPTER SIX

Science and Academia

Oak Park has long been home to a number of well-known and influential scholars, psychologists, and scientists. For starters, A.O.L. Atkin (1925–2008) was a mathematician who, while still an undergrad, cracked Nazi codes during World War II. John C. Slater (1900–1976) was a physicist, a pioneer in quantum theory, and author of *Electromagnetism*.

Because of Oak Park's proximity to Chicago's West Side, with its concentration of hospitals and health centers, many accomplished doctors have also resided in the village.

Dr. Harold A. Sofield (1900–1987), for example, invented both the "Sofield Pin," used to mend broken hips, and an innovative procedure to alleviate brittle bone disease (*Osteogenesis imperfecta*).

Dr. Frederick Tice, active in tuberculosis (TB) research, pioneered the use of the mobile chest X-ray for TB examinations.

The first African American woman to receive a doctorate in sociology, Dr. Anna Julian (1902–1994), wife of famed chemist Percy Julian, was also the first black to be awarded Phi Beta Kappa honors at the University of Pennsylvania in the early 1920s. She was a civic activist, too.

Dr. Joseph Kerwin

Born in 1932, he was America's first doctor to make a space flight and the first medical man to perform in-orbit medical research during a mission of long duration. Dr. Joseph Kerwin had been a captain in the US Navy Medical Corps in the early 1960s. The St. Giles Elementary School and Fenwick High graduate was selected as the first scientist astronaut by NASA in 1965. Kerwin spent 28 days on the 1973 Skylab mission, orbiting the Earth over 400 times and taking several space walks. When he visited his old grade school that fall, all the children sang "When Joey Comes Marching Home Again" to the first doctor astronaut.

PAGE 44 SENIOR TABULA

EDWARD WAGENKNECHT

Valedictorian; Tabula Board (4); Burke Club (4); Chicago Scholarship Contest; Northwestern Declamation Contest; Illinois Oratorical Contest; Lake Forest Speaking Contest; entered Oak Park in junior year.

"And I will roar, and they will say 'Let him roar again.'"

CHICAGO

Dr. Edward Wagenknecht (1899–2004)

The literary critic who specialized in 19th-century literature died at 104. Edward Wagenknecht was Ernest Hemingway's classmate at Oak Park High and valedictorian of their class of 1917. In his class prophecy, Hemingway satirically predicted that nonathletic, bookish Wagenknecht would eventually become a major-league ballplayer. The prolific critic and literary biographer produced over 70 books instead. While he was in his early 20s, he wrote frequent reviews for the *Atlantic Monthly* and the *Yale Review*. He developed the "psychology method" of biographical writing, focusing on his subject's personality and character, writing bios of such authors as Charles Dickens, Mark Twain, Washington Irving, Edgar Allan Poe, and Harriet Beecher Stowe. *The Movies in the Age of Innocence* was his celebration of the silent films he had enjoyed during his Oak Park adolescence. His last published work, a study of Willa Cather, appeared in 1994 when he was 95.

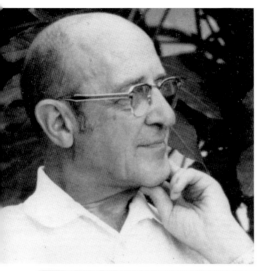

Dr. Carl Rogers (1902–1987)
He ranked in the top 10 of 20th-century psychologists—second only to Freud as a clinical psychologist. One of six children, Carl Rogers was a sickly youngster. Because his mom taught him to read at age four, he skipped first grade at Holmes School. In 1924, he married Helen Elliott, a former neighbor and Holmes classmate. Dr. Rogers was one of the founders of humanistic psychology, a person-centered approach to therapy that argues that the counselor's chief function is to listen and empathize with his or her client. A longtime professor at the University of Chicago, Rogers was also president of the American Psychological Association. His book *On Becoming a Person* (1961) is a classic in its field. Oak Park native and comedian Bob Newhart played a Rogerian psychologist on his 1970s television sitcom.

Dr. Emily Luff
One of few professional women in late-19th-century Oak Park, Dr. Emily Huff was a much-respected physician. Since she was their neighbor, she often attended the six children of Frank Lloyd Wright and routinely treated the orphans at the Hephzibah Home pro bono. She was highly regarded for her work in the treatment of scarlet fever, an infectious disease that was a major cause of childhood death before the availability of antibiotics. Huff is seen leading her horse from her barn at Chicago Avenue and Marion Street, perhaps about to make another house call, around 1896.

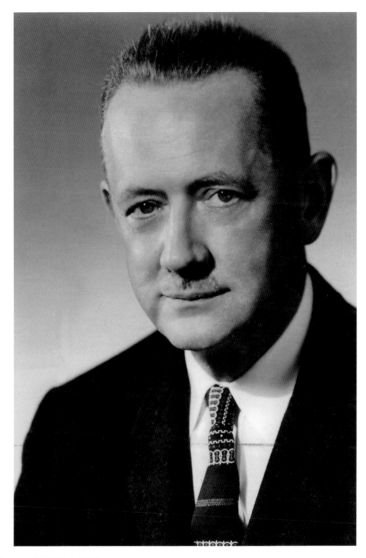

Dr. Willis Potts (1895–1968)

When he first established his general practice in Oak Park, Dr. Willis Potts quickly became restless and frustrated. When the new Art Deco–style Medical Arts Building opened in 1929, he set up his office in Suite 720. But he still felt his situation was tedious and unfulfilling. "I'm not making a difference," he complained. "I am just serving a lot of old ladies with high blood pressure and bad hearts." During the Depression, Potts began doing charity work at both Cook County and Children's Memorial Hospitals. In a single week in 1933, Potts removed 27 acute appendixes, all gratis. When he decided to specialize as a pediatric surgeon, he not only found his niche, but he also made a number of medical breakthroughs. He developed a surgical method of saving blue babies, so called because of a shortage of oxygen in their blood giving them a cyanotic or bluish color. Potts performed the first operation of this kind at Children's Memorial Hospital in 1946. He went on to save over 700 children with this procedure. The "Potts Clamp," a plastic gadget the doctor designed, was widely used to save the arms and legs of seriously wounded soldiers in the Korean War. He became president of the Chicago Heart Association, which had been founded by Oak Parker Dr. James Herrick. Dr. Potts often said, "The three main causes of heart disease are over-eating, lack of exercise, and failure to pick the right ancestors."

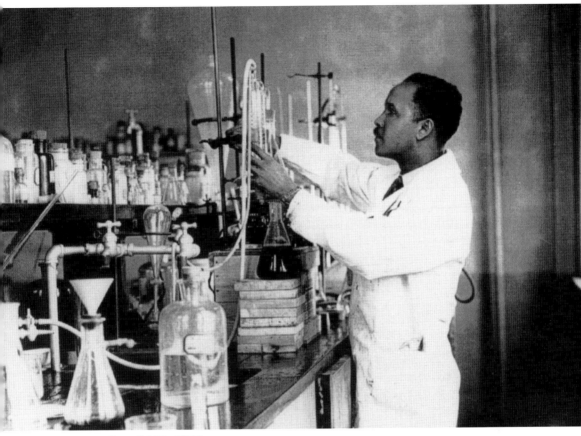

Dr. Percy Julian (1899–1975)

He was a giant in the field of chemistry. Dr. Percy Julian created medicinal uses for soybeans. There are over 130 patents registered to his name. His research resulted in the mass production of soya steroids. He also achieved a low-cost synthesis of cortisone for the treatment of rheumatoid arthritis. He developed physostigmine, a drug used to treat glaucoma. He also perfected the soya protein that became the basic of AeroFoam, the lifesaving fire extinguisher used in World War II. But despite his many achievements, Dr. Julian had lots of encounters with racism. On the lecture circuit, he often had to sleep in his car and buy food at the back door of diners because he was not allowed to eat on the premises. During the Holocaust, he assisted Jewish refugees to escape from their Nazi persecutors and come to Chicago. When Dr. Percy, his wife, Dr. Anna Julian, and their children, Percy Jr. and Faith, moved into Oak Park in 1950, their home was firebombed twice. Horrified villagers rallied around the family and protected them from that point forward. Those heinous incidents galvanized the community to confront the racism in its midst. The Julian family remained in the village and continued to pursue racial justice. In 1985, Oak Park's Nathaniel Hawthorne School was renamed for Dr. Percy Julian. In 1993, he was featured on a Black Heritage postage stamp.

Dr. James Herrick (1861–1954)

He grew up in Oak Park when the village counted its residents in the hundreds. James Herrick graduated at 16 in 1877 at the head of his class. After college, he returned to teach the classics at Oak Park High, eventually taking charge of the departments of Latin and Greek. Simultaneously, he attended Rush Medical College at night. A giant in the medical profession, Dr. Herrick was a pioneer in the identification of sickle cell anemia, a plague among African Americans. He also became one of the nation's earliest heart specialists. In 1912, he achieved world fame in the field of cardiovascular diseases when he discovered the cause of coronary thrombosis. Until that time, most heart attacks were misdiagnosed as "acute indigestion." Prior to Herrick's discoveries, a diagnosis of heart trouble was made only on the autopsy table.

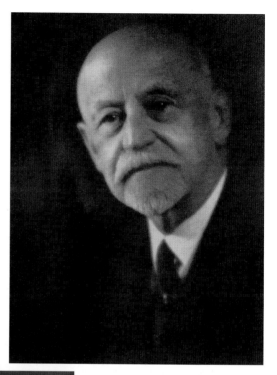

Dr. Walter Broecker

The climate pioneer, an expert in the environmental sciences, authored over 450 journal articles and 10 books. But Dr. Walter Broecker (born in 1931) is best known for his discovery of the ocean's role in accelerating abrupt climate changes. He developed the idea of a global "conveyor belt" linking the circulation of the global ocean. In 1975, Broecker coined the term *global warming* in his article "Climate Change: Are We on the Brink of a Pronounced Global Warming?" in *Science* magazine.

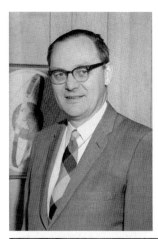

Fred Doyle

NASA scientist and space photographer Frederick C. Doyle's systems for orbital photography have garnered much priceless data from outer space. His innovations were used on Skylab and five Apollo missions, which included full-scale mapping of the mountains of the moon. While in the Army during World War II, Doyle prepared target charts for the aerial bombing of Japan. He became involved in the burgeoning space program in 1954 when he served as leader of the US Air Force solar eclipse expedition to Labrador. Next, he was asked to be chair of NASA's Apollo Orbital Science Photographic Team. From 1969 to 1973, he planned the camera systems and directed all the orbital science photography for Apollo lunar missions 13 through 17.

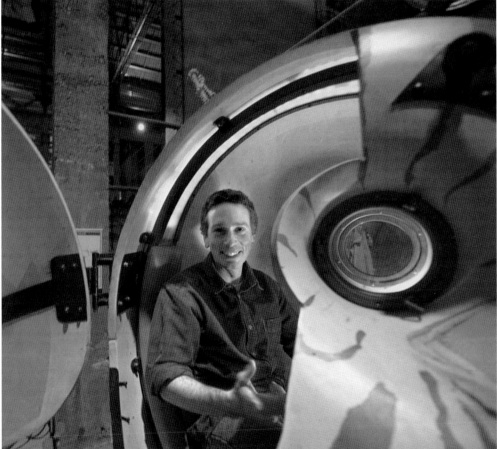

Dr. Chad Trujillo

Dr. Chad Trujillo (born in 1973) is the codiscoverer of the dwarf planet Eris, an almost perfect twin of Pluto. Trujillo is an astronomer at the Gemini Observatory in Hawaii. He has specialized in the outer area of the solar system, examining the orbits of TNOs (Trans-Neptunian Objects). The main-belt asteroid 12101 Trujillo is named for him.

Dr. Rupert Wenzel (1915–2006)

While a student at YMCA Central College in the 1930s, Rupert Wenzel got regular work on the radio, playing supporting roles on serials like *Jack Armstrong, All-American Boy*. As a white officer commanding a segregated medical unit of African American soldiers in World War II and, later, as a civic leader in Oak Park, "Rupe" crusaded against racial and religious discrimination. He became a village trustee during the turbulent 1960s when rapid racial change (white flight) had been the norm in the Chicago neighborhoods just east of Oak Park. When some villagers tried to keep blacks from moving in, Wenzel, despite receiving death threats, was instrumental in establishing Oak Park's groundbreaking open housing ordinance. Wenzel was also internationally recognized as a major authority on insects. He joined the staff of the Field Museum of Natural History in 1940 and, eventually, became the head entomologist and chair of the Department of Zoology. He authored many studies of histerid beetles and bat flies and was an expert on the control of numerous parasites. In his 80s, he supervised the computerization of data about the Field Museum's vast insect collection. Wenzel himself discovered several hundred species. His bug expertise also enabled him to help Oak Park devise its battle plan against the Dutch elm beetle that was attacking the village's tree-lined streets.

Dr. John Tope (1845–1910)

The force behind the creation of Oak Park Hospital in 1904 was Dr. John Tope. But because of opposition to having a hospital in a totally residential section, the project got stalled for three years. Fearful residents of north Oak Park rejected his plan for a hospital, but Tope persevered. It was 1907 before the Catholic Sisters of Misericordia opened the 90-bed facility, the first hospital in the area. Tope, who had enlisted in the Union army as a youth of 15, fought in the battles of Antietam and Vicksburg. He was with General Sherman in the Atlanta campaign and his infamous March to the Sea. After the Civil War, Tope was in the second intern class at Cook County Hospital (1869) and opened a practice in 1876. He served as superintendent of the Dunning Insane Asylum, a public sanitarium north of Oak Park. Dr. Tope's 14-room Queen Anne–style home was a showplace with seven fireplaces and Tiffany art-glass windows. Located just west of the Oak Park Post Office, it was demolished in 1960 to make room for a new village parking lot. In 1997, Rush University Medical Center assumed full management of Oak Park Hospital, its services, and programs.

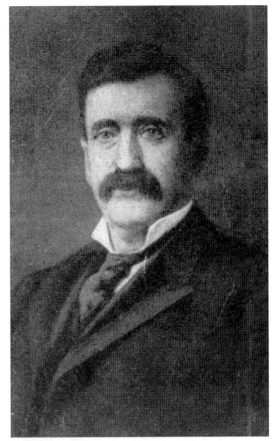

OAK PARK HOSPITAL
OAK PARK, ILL.

OAK PARK HOSPITAL

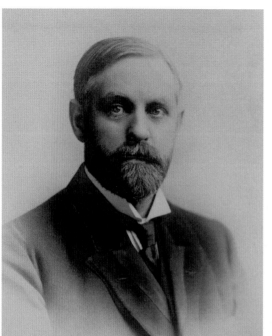

Dr. William Barton (1861–1939)

While still in his teens, William Barton began his career as a "log cabin teacher" in the hills of Appalachia. On the weekends, he was a fiery circuit-riding preacher. He served as pastor of Oak Park's First Congregational Church for 25 years (1899–1924). A leading Lincoln scholar of the era, Barton wrote 12 books on the 16th president, including best seller *The Women Lincoln Loved*. He also wrote *The Life of Clara Barton*, which is about his cousin. After his retirement, he became one of the first radio preachers and enjoyed a wide fan base. Barton was a friend to both Presidents Coolidge and Hoover. In 1975, Barton's First Congregational Church merged with the First Presbyterian Church to become First United Church of Oak Park.

Bruce Barton (1886–1967)

Son of Oak Park theologian and Lincoln scholar Dr. William Barton, Bruce Barton helped create the modern advertising industry, as a founder of giant BBDO (Batten, Barton, Durstine & Osborn), which first popularized radio advertising and made Betty Crocker a household name. He contributed many innovations in the young field of commercial advertising, such as promoting products on radio programs. Barton was also a scholarly religious writer who wrote several best-selling books that personalized Jesus for the average person. *The Man Nobody Knows* (1924) depicts Christ as a virile business executive selling his message to millions. Republican Barton was also an anti–New Deal congressman from New York (1937–1941) and a vehement opponent of Pres. Franklin D. Roosevelt.

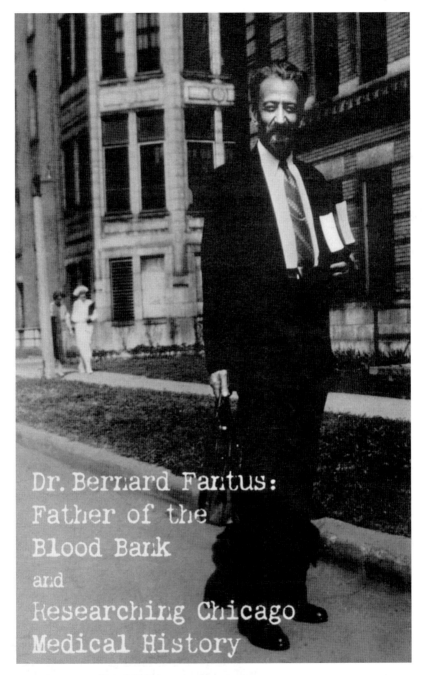

Dr. Bernard Fantus:
Father of the
Blood Bank
and
Researching Chicago
Medical History

Dr. Bernard Fantus (1876–1940)

Born in Budapest, Hungary, Dr. Bernard Fantus earned his doctorate of medicine degree from the University of Illinois in 1899. He established the first hospital blood bank in the nation at Chicago's Cook County Hospital in 1937. Prior to this time, the inability to store blood made emergency surgeries possible only if a blood donor were standing by. Major surgery could be performed only if the blood donor were waiting at the operating room door. Fantus also pioneered the use of medication that "tastes like candy" for children.

INDEX